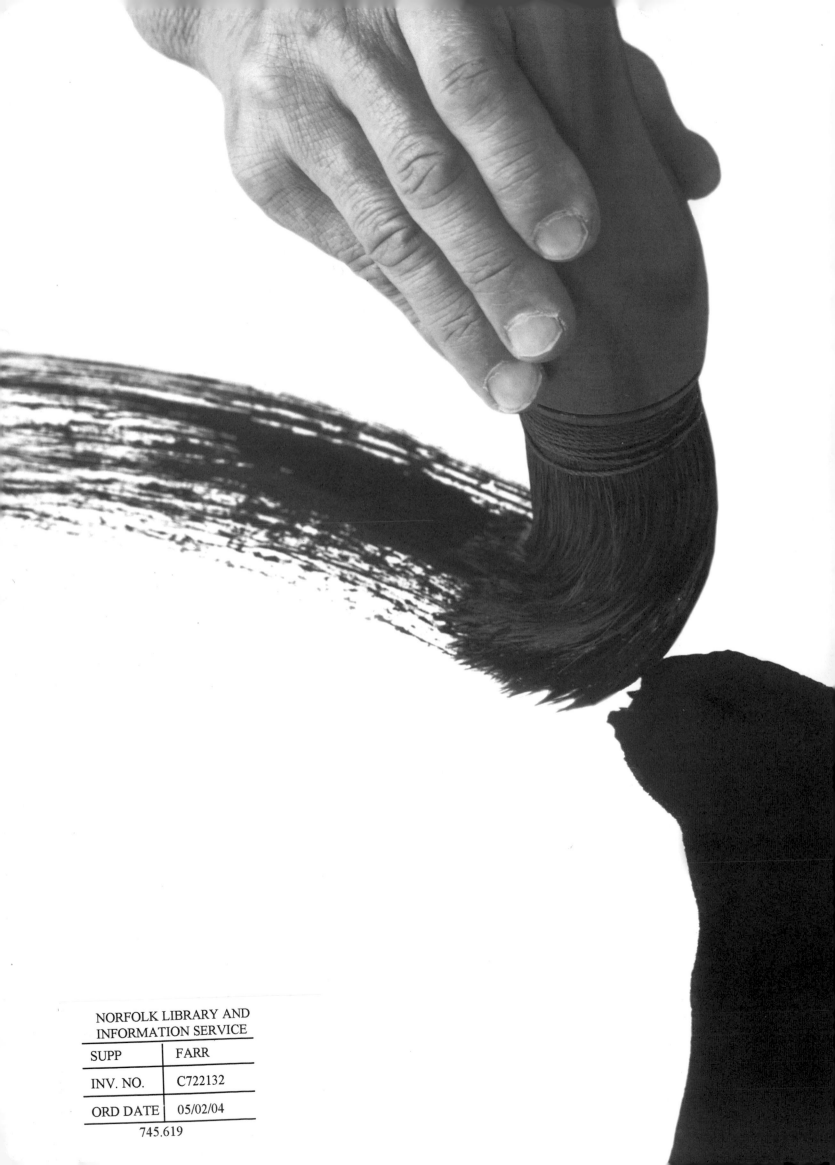

ZEN
BRUSHWORK

Focusing the Mind with Calligraphy and Painting

TANCHŪ TERAYAMA

Translated by
Thomas F. Judge
John Stevens

KODANSHA INTERNATIONAL
Tokyo · New York · London

CONTENTS

Introduction 7

PART I BACKGROUND 9

What is Zen Calligraphy? 10
The Evolution of *Kanji* 11
The Fundamentals of Calligraphy 12
The Four Treasures of Calligraphy 13
Hitsuzendō 14

PART II PREPARATION—WARMING UP AND DEVELOPING *KI* 23

The Zen Line 24
Yōki-hō: A Method of Developing *Ki* and Warming-Up 25
 WARM-UP EXERCISE 1: Yōki-hō: The Long Version 27
 WARM-UP EXERCISE 2: The Short Form of Yōki-hō: A Five-Minute Exercise 29
 WARM-UP EXERCISE 3: Kūsho: Writing in the Air 30

PART **III** ZEN CALLIGRAPHY AND PAINTING 31

BASIC PRACTICE 32

The Zen Line and Its Applications 32

EXERCISE 1: *Mujibō* (The Zen Line) 32

EXERCISE 2: *Ensō* (The Zen Circle) 34

EXERCISE 3: Horizontal and Vertical Lines 37

EXERCISE 4: Fine Lines 39

Tensho (Seal Script) 40

EXERCISE 5: *Sō* (Grass) and a Practice Line 40

Kaisho (Standard Script) 41

EXERCISE 6: *Sho* (Calligraphy) and Practice Lines 41

FURTHER PRACTICE 43

Sōsho (Grass Script) 43

EXERCISE 7: *Mu* (Nothing) 43

EXERCISE 8: *Hana* (Flower) 45

EXERCISE 9: *Kū* (Emptiness) 47

EXERCISE 10: *Mu Ichi Motsu* (Owning No-thing) 49

EXERCISE 11: *Ichigyō Zanmai* (Be in the Moment) 51

Writing Western Script 52

EXERCISE 12: Writing Western Script: ABC 52

EXERCISE 13: *Shodō* (Calligraphy) 54

PAINTING 55

EXERCISE 14: Orchid 55

EXERCISE 15: Bamboo 58

EXERCISE 16: Plum Blossoms (with inscription) 61

EXERCISE 17: Mount Fuji 63

EXERCISE 18: Daruma 65

EXERCISE 19: Wall-Gazing Daruma 70

EXERCISE 20: "One-Stroke" Daruma 72

EXERCISE 21: *Ji-Wa-Choku* (Compassion, Harmony, Honesty) 73

PART **IV** APPRECIATION 75

WORKS BY OLD MASTERS 76

WORKS BY TERAYAMA TANCHŪ 88

Glossary 95

Note: With the exception of the contemporary names on this page, the jacket, and the title page, all Japanese names appear in the traditional order, surname preceding given name. Ages of the artists are reckoned in the Japanese manner: a person is considered one year of age at birth so his or her given age has one more year added to it than when calculated according to the Western counting system.

Daruma by Fūgai (page 68) and *Daruma* by Miyamoto Musashi (page 85) copyright © Eisei-Bunko Museum.

Exercises demonstrated by the auther and Sarah Moate.
Process photographs by Masatoshi Taya.
Photography on pages 2 through 5 by Mizuho Kuwata.

Distributed in the United States by Kodansha America, Inc., 575 Lexington Avenue, New York, N.Y. 10022, and in the United Kingdom and continental Europe by Kodansha Europe Ltd., Tavern Quay, Rope Street, London SE16 7TX.

Published by Kodansha International Ltd., 17–14, Otowa 1-chome, Bunkyo-ku, Tokyo 112-8652, and Kodansha America, Inc.

First edition, 2003
03 04 05 06 07 08 09 10 10 9 8 7 6 5 4 3 2 1

www.thejapanpage.com

INTRODUCTION

Sho, the art of brush calligraphy, has always been highly regarded as an art form in the Far East. Although the hand of the artist can be seen in any work of art, it has long been said that *sho* is the artist. The pliant hairs of the brush, the life force of the carbon that constitutes the ink, and the spontaneity of the brushed letters all work together to express the spirit of the calligrapher.

The calligrapher must become one with the brush if the brush is to come to life. The ink can be thought of as a subtle substance that expresses life and death, and the brushstroke as an opportunity for expression that embodies the whole of the artist.

To become one with the brush means eliminating the self and infusing the ink with the spirit to make each brushstroke resonate with vital energy. The ability to manifest one's strength comes only through dedicated practice.

As a basic exercise, drawing a single straight line is ideal. This line is called the *mujibō*, the "Zen line," or the "line of nothingness." This single stroke can be taken as the basis of *sho*. To draw a single stroke does not call for any special technique; all that is required is simply to grasp the brush firmly between the thumb and fingers, keep the brush shaft vertical, and then, while slowly exhaling, pull the brush with all your strength, as if dragging a heavy stone. As with many art forms, *sho* can be very revealing. A person whose heart is clouded will not be able to draw a line that shines with purity. A person shallow in experience or cultivation cannot draw a line that reveals depth. A person lacking vitality will not draw a line that resonates with energy. Even a single straight line can be a mirror of the spirit.

In Chinese art, *sho* and painting are thought of as one. All paintings begin from *sho*: the brushstrokes that make up the characters in calligraphy are the same strokes that form the elements of an ink painting. Anyone who can brush a single vibrant stroke can apply this ability to brush an *ensō* (Zen circle), or to paint an orchid, bamboo, or landscape.

Writing words and phrases in *kanji* (Chinese characters), which themselves hold a certain mystique, raises calligraphy to a higher, spiritual level. This spirituality is

expressed in *sho* through creative brushwork that plays on the shape and nuanced meanings of the *kanji*.

Over the centuries, Zen monks and nuns have brushed many classic works of calligraphy and painting. Calligraphy has long been appreciated as an art form in the Western world as well. Some Western artists, such as the French fauvist expressionist Georges Rouault (1871–1958) and Spanish surrealist Joan Miró (1893–1983), were drawn toward calligraphy in their later years. For those who are fascinated with art, *sho* can be seen as a form of true artistic expression.

Hitsuzendō, the Way of the Zen Brush, is a form of calligraphy based on the principles of Zen. Artists who practice Hitsuzendō use *sho* as a means of representing the relationship between the mind, body, and universe. It may take a lifetime to develop brushwork that truly expresses *ki*, the basic life energy or spiritual life force. With practice, one's efforts in Hitsuzendō increase in depth and vitality with each passing year.

Through methods such as establishing high goals for oneself, working on breathing, and delving deeply into your inner resources to find your true expression, the practitioner of Hitsuzendō is able to express universal mind and body with each brushstroke, and in the process, achieves ever greater profundity.

Terayama Tanchū

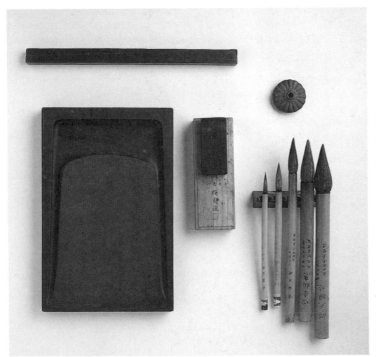

The traditional tools for calligraphy (*clockwise from the upper left corner*): paperweight, water holder, brushes, ink stick, and inkstone.

BACKGROUND

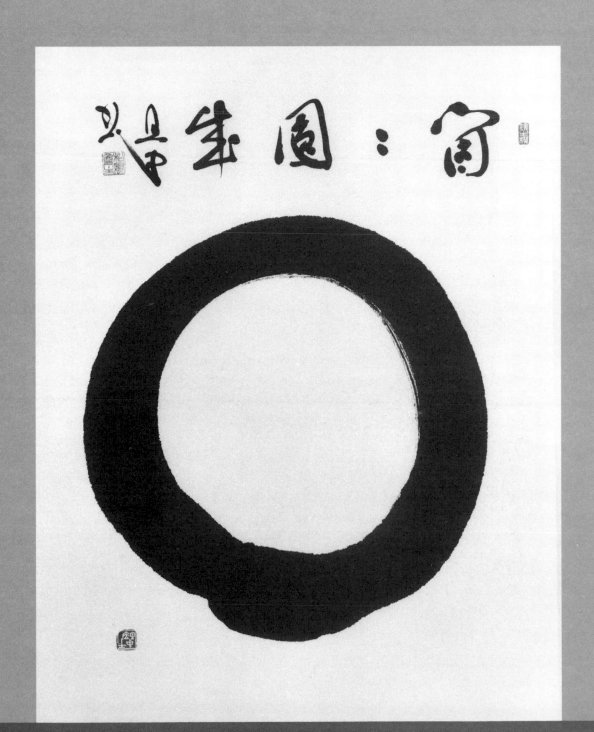

WHAT IS ZEN CALLIGRAPHY?

Calligraphy (*shō*) is a formative art based on writing. It includes not only writing that is beautiful, but phrases that are novel and interesting. According to the Japanese philosopher Nishida Kitarō (1870–1945; see figure 1), true creativity is not the product of a conscious effort but rather the "phenomenon of life itself." True creation must arise from *mu-shin*, or the state of "no-mind," a state beyond thought, emotions, and expectations. Work that is produced through conscious effort is ultimately devoid of life.

Zen calligraphy in particular must spring from *shōnen sōzoku*, a Buddhist term equivalent to "true thought." *Shōnen* is a state of full concentration that is devoid of thoughts and ideas, while *sōzoku* here means "free-flowing continuity." Greatness in brushwork cannot be achieved through conscious effort; it is only achieved through the states of *mu-shin* and *shōnen sōzuku*, or "no-mind" and a continuous state free of the thoughts and ideas that distract the mind.

Zen calligraphy differs from other calligraphic disciplines as it is focused on the realization of "no-mind." Furthermore, in contrast to *sho*, which uses Chinese characters as a basis, it is the expression of Zen through a brush, whether the result is a single stroke, a Zen circle, or an ink painting. While *sho* is restricted to brushed writing, Zen calligraphy extends to other forms of brushwork.

Nearly all calligraphy today is born of conscious attention to an aesthetic concept, but we rarely find lines that are truly alive. In contrast, the calligraphy of Zen masters such as Daitō Kokushi (1282–1337; founder of Daitokuji temple in Kyoto) or Ikkyū Sojun (1394–1481) resonates with the energy of "no-mind" achieved through complete concentration. In these works, the lines are filled with vitality and the shapes are fresh and original.

Sen no Rikyū (1522–91), who established many of the basic precepts of the tea ceremony, held that nothing surpassed Zen calligraphy as a subject for display in the alcove of the tea room. He undoubtedly felt that only art works that reflect the eternal vitality of Zen writings could encourage the mind toward enlightenment.

Rikyū recognized that calligraphy necessarily demands the highest level of spirituality. A line that manifests clarity cannot be drawn if the heart is clouded by worldly concerns; a stroke cannot be brushed with resolution if the heart is agitated; and calligraphy that reveals depth cannot be produced if cultivation and experience are shallow.

To write *kanji* characters that resonate and demonstrate their deeper meaning, one's own mind must achieve unity with the meaning of the words—a requirement that calls for a higher level of spirituality. The calligrapher, therefore, must strive for the state of "no-mind" through meditation and contemplation.

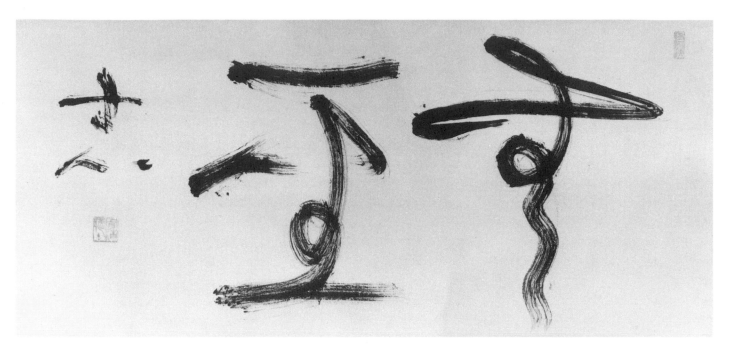

1 | *Nothing Sacred!* **by Nishida Kitarō**
97 x 180 *inches* (38 x 71 *cm*)
Mushō 無聖

When the emperor of China asked Bodhidharma, "What is the first principle of Buddhism?" Bodhidharma replied: "Vast emptiness, nothing sacred!" ("*Kakunen mushō!*") The two characters in this work read *mu* and *shō*, the last half of Bodhidharma 's reply, which could also be translated as "Nothing special!" This is the work of Nishida Kitarō, generally considered to be the leading Japanese philosopher of the twentieth century. The brushstrokes here are simple and unaffected, created with a light touch, and the two characters are well balanced.

The Evolution of *Kanji*

The art of calligraphy has its origins in China, where some 3,500 years ago pictographs were carved into the carapaces of tortoises or the scapulae of cows as part of an oracular ritual. Such writing is now called *kōkotsu-bun*, or "shell-and-bone script" (see page 93). Pictographs that were incised in bronze vessels are called *kin-bun*, which means "metal script" or "bronze script." These early forms of pictographs, collectively known as *kinkei-bun*, feature characters that lack uniformity in size or form but still convey a certain charm as they often maintain a clear connection to the object or idea they represent.

From the thirteenth to fourth centuries B.C., the many different ideograms were gradually standardized to a form called *daiten* (greater seal script), and at the time of the Ch'in Dynasty (221–206 B.C.) the characters were further consolidated into the *shōten* (lesser seal script), which is today most commonly used in seals. Combined, these two styles may be thought of as *tensho* (seal script). During the Han Dynasty (206 B.C.–A.D. 220), the characters further evolved into *reisho* (scribe's, or clerical, script), a form that was brushed onto bamboo or wooden strips and characterized by strong horizontal strokes.

Sōsho (grass, or cursive, script) developed as a rapidly written form of *reisho*, and it was followed by *kaisho* (standard script) and *gyōsho*, (semicursive, or running, script), the forms in common use today. In *kaisho* the characters are written neatly and independently, while in *gyōsho* the dots and strokes tend to run together in an unbroken line. In *sōsho*, the simplification of the characters is so extreme that the characters can rarely be read by anyone who has not studied calligraphy.

Having originated in China, the ideograms are called *kanji* in Japanese, which literally means "Han letters," as the character for the Han Dynasty is pronounced *kan* in Japanese. *Sōsho* was further adapted and simplified by the Japanese to create the *hiragana* syllabary, which represents inflections and particles that could not be easily represented by *kanji*. Written Japanese today is chiefly a mixture of *kanji* and *kana*.

	篆書 TENSHO Seal script	隸書 REISHO Scribe's script	楷書 KAISHO Standard script	行書 GYŌSHO Semicursive script	草書 SŌSHO Grass script
山 *yama* mountain					
心 *kokoro* heart					
大 *dai* large/great					

The Fundamentals of Calligraphy

We have already defined calligraphy as a formative art that takes characters and lines as its raw material, but the calligrapher must also be aware of the origin of these lines. Before there was anything, there was the void—a state we call *konton-kaiki*, which

can be thought of as "the creation, or birth, of form from the primordial void, a state of 'chaos' that preceded the separation of Heaven and Earth." The lines of calligraphy emerge from this void, beginning the instant the brush touches the paper.

As a rule, the brush begins its journey with the brush tip moving in the direction opposite that of the intended stroke, then quickly reverses course. In this way, the trace left by the tip of the brush on first contact with the paper is concealed within the stroke.

When the tip of the brush reaches the last point of a stroke, the brush is slowly withdrawn, leaving a lingering echo of its passage in its wake. This is referred to as *shūhitsu*, or "withdrawing the brush." Throughout the stroke, the brush must be moved without a break in concentration.

The Four Treasures of Calligraphy

The materials necessary for practicing *sho* are *hitsu-boku-ken-shi*—brush, ink, inkstone, and paper. These are sometimes referred to as the four treasures of calligraphy.

A medium-sized brush made from *yōmō* (sheep's hair) and measuring about 5/8 inch (1.5 centimeters) in diameter at the part of the shaft closest to the bristles is best for writing on ordinary *hanshi*, sheets of Japanese paper that measure approximately 10 by 13 inches (26 by 53 centimeters). However, beginners in Zen calligraphy will benefit from practice with a large brush as it encourages writing with one's full strength, combining a concerted effort of mind and body. For this purpose, the ideal brush would be one made of horsehair, measuring up to 2 inches (5 centimeters) in diameter at the shaft.

Ink is obtained by rubbing an ink stick in the depression of an inkstone. Ink sticks come in many varieties and are used for different purposes: *yuen-boku* (oil-soot ink) is used for calligraphy, and *shōen-boku* (pine-smoke ink) is best suited to painting. Both of these ink sticks are composed of extremely fine carbon particles. The best ink is produced by old ink sticks in which the glue has "seasoned." Grinding your own ink assists not only in producing a good ink but in preparing the spirit for brushwork. However, since Zen calligraphy calls for plenty of ink, *boku-jū*, a marketed pre-made ink, is often used for convenience.

An inkstone (*suzuri*) is needed to grind an ink stick and allow the calligrapher to align the bristles of the brush. A cheap *suzuri* is made from compressed pulverized stone, while a fine *suzuri* may be carved from any of a wide variety of natural stones found in both China and Japan. A *tankei suzuri*, made from a dark purple riverbed stone from Guangdong province in China, has very fine and uniform *hōbō* (grain) and is considered to rank among the best inkstones. But when practicing Zen calligraphy with ready-made ink, any dish deep enough to charge the brush fully will be sufficient.

The ideal paper is Chinese *gasenshi* rice paper, which has strong fibers and a fine and uniform surface. *Washi*, a Japanese paper made principally from *kōzo* (paper mulberry), is also a good choice. However, learning to use the brush with one's entire mind and body is really the key to good brushwork, and, in order to practice, a beginner may even work on newspaper, particularly when warming up. A clean copy calls for *gasenshi* (white calligraphy paper), a good size being a *hansetsu* sheet that measures 14 by 53 inches (35 by 135 centimeters).

Hitsuzendō

Modern calligraphy is rated highly if the *kanji* are well-proportioned and pleasing to look at. In contrast, Hitsuzendō—the school of Zen calligraphy to which I belong and which I will introduce in this book—must demonstrate calligraphy that breathes with the energy and vitality of eternal life.

Such writing is not the product of conscious effort. Hitsuzendō is an endeavor in which the self is forgotten; it is the product of a single-minded concentration that unites the individual with the highest reality. In Japanese, the Buddhist term for this state is *sammai*, a word derived from the Sanskrit term *samādhi*.

Perhaps at some time in the past, all calligraphers strove for this enlightened state, and no difference existed between *sho* and the present-day practice of Hitsuzendō. Concern for aesthetic beauty is the single greatest divide between modern *sho* and Hitsuzendō.

Hitsuzendō was inspired by the life and teachings of Yamaoka Tesshū (1836–88; see figure 2). Tesshū was a master of the sword, Zen, and the brush. Following his enlightenment at the age of forty-five, he wrote: "I realized that the Ways of the sword, Zen, and the brush are not separate paths but rather different functions of one truth." Tesshū's practice of the three ways can be characterized as follows: The Sword of No Sword, the Zen of No Obstacles, and the Brush of No Method.

As a student of the brush, Tesshū spent many years copying the calligraphy of the Chinese master Wang Hsi-chih (321–79; see figure 3). No specimen of Hsi-chih's calligraphy exists today, but the reproduction of a letter of his, called the *Sōranjō*, is considered to be one of the truest representations of his brushwork.

As a young man, Tesshū studied calligraphy under the Jubokudō master Iwasa Ittei. According to tradition, the Jubokudō School of Calligraphy was founded by the Buddhist patriarch Kūkai (774–835; see figure 4), also known as Kōbō Daishi, the founder of the esoteric Shingon sect of Buddhism. Kūkai was a renowned master of calligraphy and Tesshū is known to have studied his calligraphic works.

The actual founder of Hitsuzendō is Yokoyama Tenkei (1885–1966; see figure 5). After studying calligraphy and Zen for many years, Tenkei established Hitsuzendō as a "practice to uncover one's original self through the brush." He believed that society could be improved by the study and practice of calligraphy.

In addition to learning Hitsuzendō from Tenkei, I also trained in Zen and swordsmanship under Ōmori Sōgen (1904–94; see figure 6). Ōmori was one of the most important Rinzai Zen priests of the twentieth century. He wrote a biography of Tesshū, as well as many other works on Zen practice and philosophy.

While not directly of the Hitsuzendō lineage, the brushwork of Zen masters Ikkyū (see figure 7), Daitō (see figure 8), and Hakuin (1685–1768; see figure 9 and page 69) are important sources of inspiration for Hitsuzendō practitioners.

It is hoped that collectively the representative works in this section will convey the spirit of Zen brushwork embraced by Hitsuzendō.

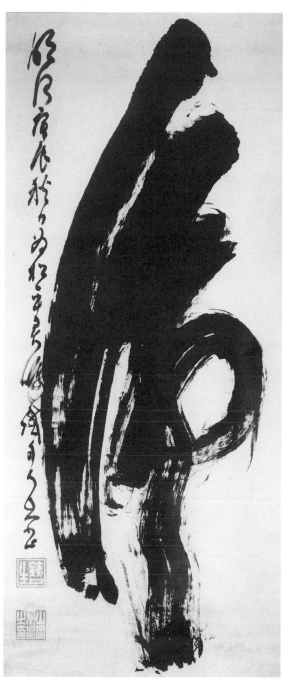
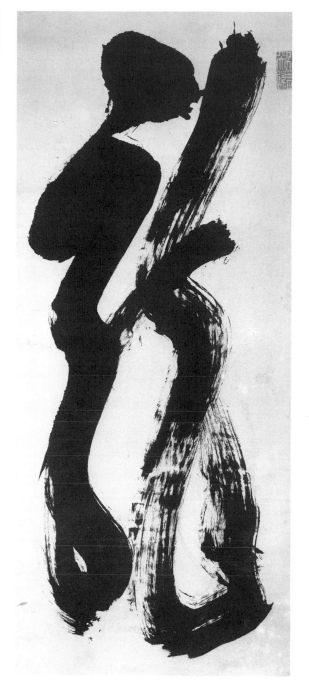

2 *Dragon and Tiger* by Yamaoka Tesshū

53 x 24 *inches* (135 x 59 *cm*)

Ryūko 龍虎

Here we have two characters of massive proportions: *Dragon* (*right*) and *Tiger* (*left*), brushed about six months after Tesshū attained enlightenment. The brushstrokes overflow with energy, looking as if they could shatter heaven and earth. We can sense here that Tesshū himself "became" the dragon and the tiger when he created the characters. Tesshū instructed his calligraphy disciples to "forget body and soul and gather all things of heaven and earth into this single brush!"

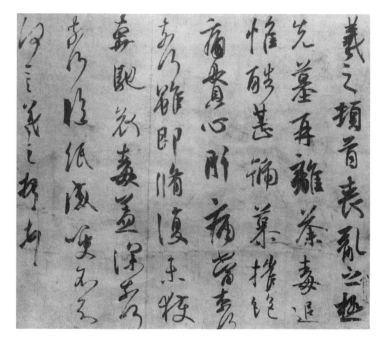

3 Section of the *Sōranjō* by Wang Hsi-chih

10 x 23 *inches* (26 x 58 *cm*)

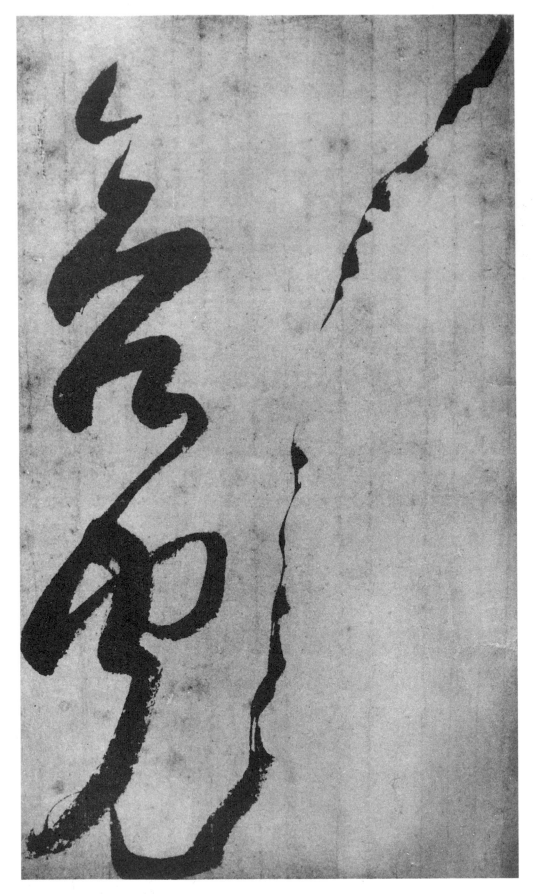

4 | *Cherish the Light* **by Kūkai**

11 x 6 inches (29 x 15 cm)

Gankō 含光

This calligraphy from Kūkai's work *Zayūmei* consists of two characters, *fukumu* and *hikari*. Read together these characters are pronounced *gankō* and mean "cherish the light." The cursive brushwork is extraordinarily majestic, rhythmical, and lucid—indeed the work of an enlightened Buddhist master. It is likely that this work was created by Kūkai in his mid-forties.

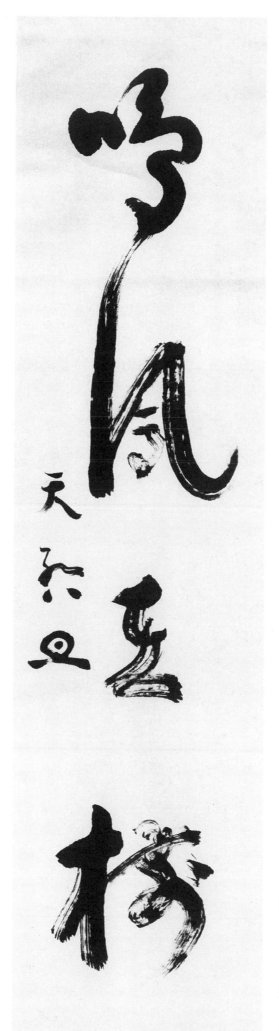

5 | *Phoenix Sings in a Tree*
by Yokoyama Tenkei
52 x 13 *inches* (133 x 33 *cm*)
Meihō Zaiju　鳴鳳在樹

This example of Yokoyama Tenkei's calligraphy was written about one year before his death. The lines are clear, bright, and settled.

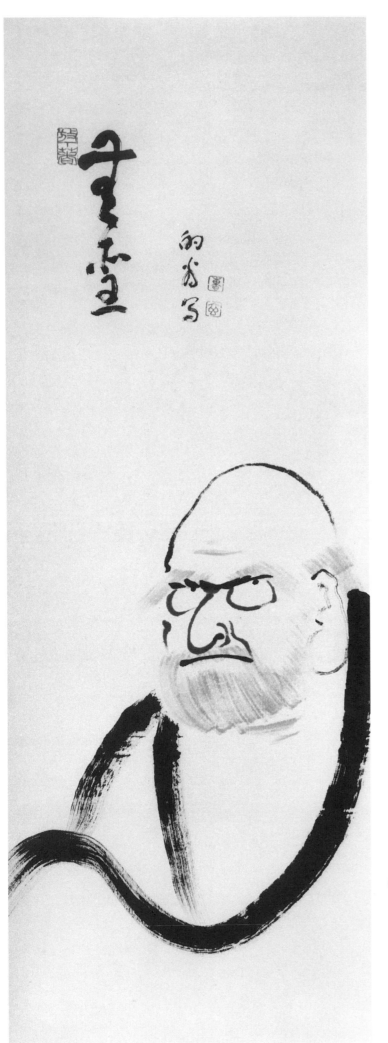

6 *Daruma* by Ōmori Sōgen
INSCRIPTION: **"Nothing Sacred!"**
Mushō 無聖

37 x 11 inches (95 x 28 cm)

This is Sōgen's interpretation of Bodhidharma, the Grand Patriarch of Zen. The inscription says, "Nothing sacred!" These words were part of Bodhidharma's reply when the emperor of China asked, "What is the first principle of Buddhism?" Bodhidharma's full answer was: "Vast emptiness, absolutely nothing!"

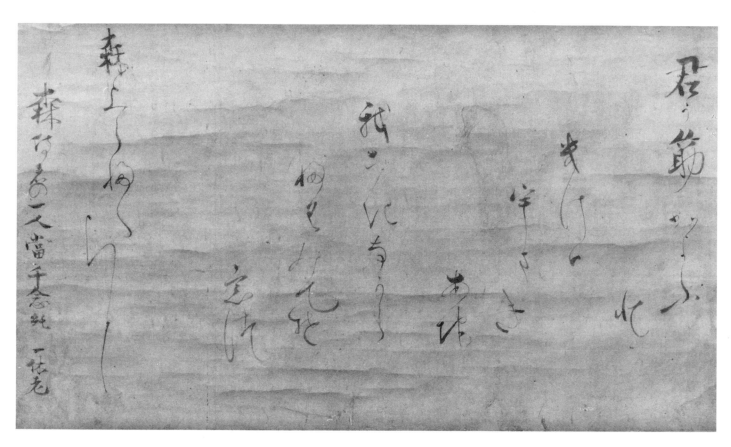

7 | **Cursive script by Ikkyū** 12 x 21 *inches* (30 x 53 *cm*)

This love letter written by Ikkyū to Lady Mori, brushed in supple cursive *kana* script, seems to dance across the paper.

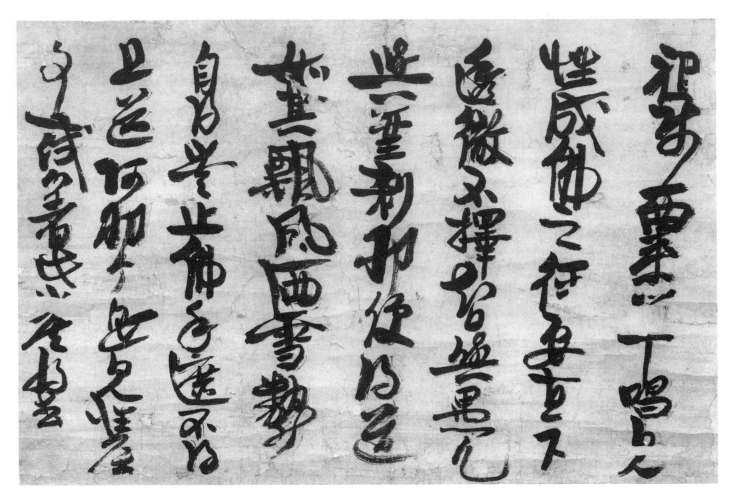

8 | **Dharma words by Daitō** 13 x 19 *inches* (32 x 49 *cm*)

At first glance, this bold calligraphy by Daitō seems to be the exact opposite of Ikkyū's light touch with the brush, and upon closer examination we can sense Daitō's careful and scrupulous personality.

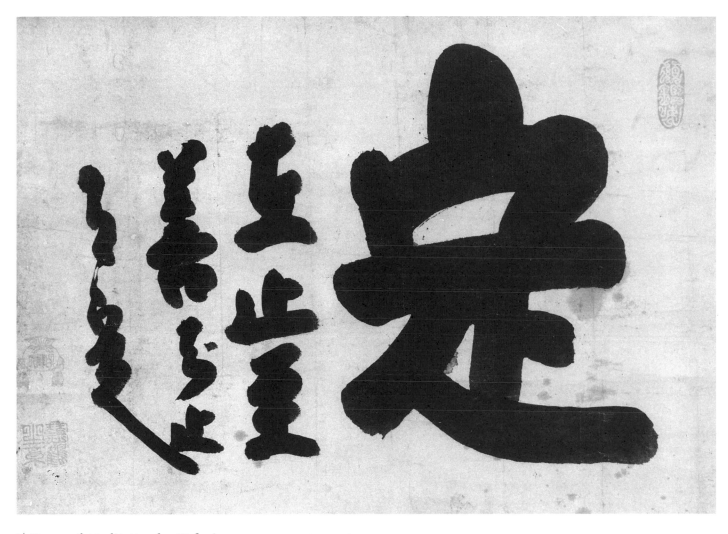

9 | *Tranquil Meditation* **by Hakuin** 15 x 21 *inches* (38 x 54 *cm*)
| **Sadamaru/Jō** 定

Hakuin was one of the greatest Zen monks of Japan, and both a Zen master and a Zen artist. The large character *sadamaru* means "settled," but it can also be read *jō,* meaning "tranquil meditation." This character appears to have emerged from the void of "no-mind" with a perfect natural rhythm. The phrase comes from the Confucian analects: "Settled—fix yourself in the best place, know exactly where to stop." The work was written when Hakuin was eighty years old.

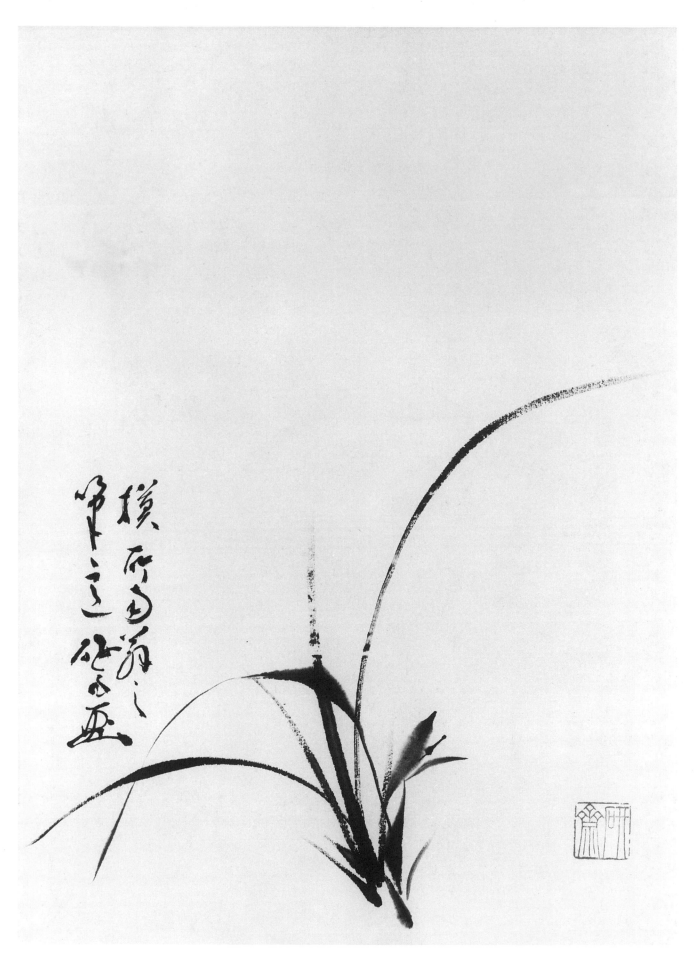

10| *Orchid* by Yamada Kensai 16 x 12 *inches* (40 x 30 *cm*)

This painting by Kensai bears the inscription, "Brushed with the same intention as Zheng Si-xiao." Zheng Si-xiao (J: Shonan) was a thirteenth-century Chinese artist forcibly drafted into the Mongolian army. To overcome his resentment and anger, he painted an orchid every day. Kensai (1911–74) followed his example, using the brush to liberate himself from distracting and petty thoughts.

PREPARATION
Warming-Up and Developing *Ki*

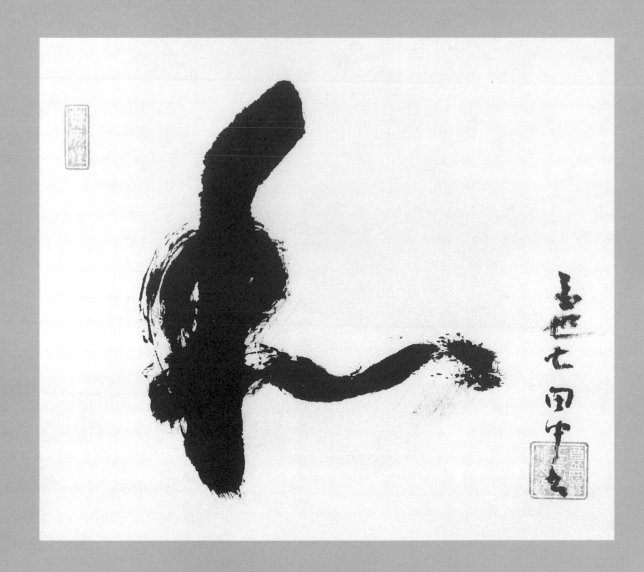

The Zen Line

In the practice of Hitsuzendō, we begin by brushing a single, large, straight stroke, executed with full concentration of body and mind, to facilitate the attainment of "no-mind." This stroke is called *mujibō*, the "line of nothingness," or the "Zen line," and is introduced in EXERCISE 1 on page 32. The *mujibō* is the basis of Hitsuzendō; the *ensō* (Zen circle), calligraphy, and paintings are, in essence, all applications of this single line.

The person who can brush one stroke that is truly "alive" will find it has many applications. It can be used in calligraphy or, perhaps, for an image of an orchid. In Hitsuzendō, calligraphy and ink painting are one and the same. Although someone with an eye for art may have a slight advantage, Zen brushwork, like painting, transcends culture. It can be appreciated and practiced by anyone with a desire to approach it. Begin by brushing the Zen line and simple shapes, and with time you will capture the spirit of your subject.

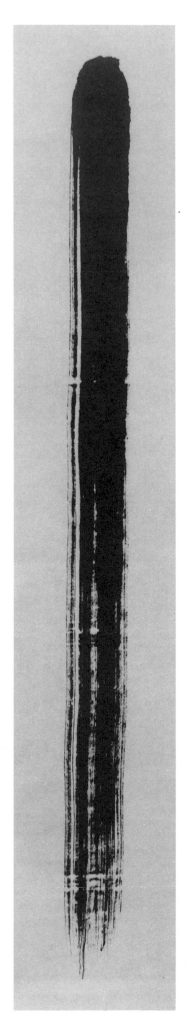
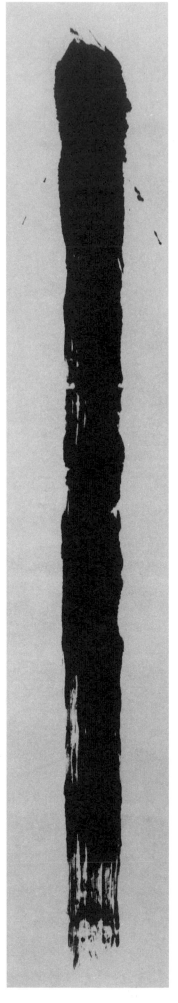

Two *Mujibō*

Here are two *mujibō*, written with the same brush, the same ink, on the same paper, at almost the same time, but by two different practitioners of Hitsuzendō. The line on the left appears bright and fresh and projects a sense of refinement. The line on the right is rather muddied and uneven, lacking power and gravity. The vibrancy and richness of the first line reflects years of training in the art of the Zen brush. But while it is technically superior, it is merely a clean practice stroke, and as such lacks depth and character that may appear when the same energy is applied to a chosen theme. What transforms good strokes is the ability to convey the essence of a subject—whether it is a Zen circle, *kanji*, or painting—with feeling and substance.

Yōki-hō: A Method for Developing *Ki* and Warming Up

Yamaoka Tesshū's writing improved every year until his life was cut short by stomach cancer at the age of fifty-three. The Zen master Hakuin passed away at the age of eighty-four, but his writing did not truly reveal his inner self until he had reached the age of eighty. The Buddhist nun Ōtagaki Rengetsu (1791–1875) produced her finest work at the age of eighty-five, the last year of her life. The Rinzai Zen master Yamamoto Gempō (1866–1961) showed his true ability at the age of ninety, and the Sōtō Zen master Katō Kōzan (1876–1971) at ninety-five. The sculptor Hirakushi Denchū (1872–1979) reached his prime at the age of one hundred, and his work showed greater depth each year until his death at one hundred and seven.

The world of the brush is closely related to *ki*, the basic energy or spiritual force of life within every human being. The realm of *ki* is beyond physical power—it is governed by will and by breath. *Ki* is the very foundation of life.

Yōki-hō, or "the *ki*-nurturing method," is a sophisticated warm-up exercise designed to allow the body and mind to relax and focus. It is directed toward releasing tension at key energy points to allow *ki* to flow throughout the body. This method focuses on the body's center, or *tanden*, a point about two and a half inches below the navel. In Japan, the *tanden* is often called by the more general term for the lower abdomen, *hara*. The other key points in Yōki-hō include the *hyakue*, a point on the crown of the head; the *yūsen*, points at the center of the soles of the feet; and the *rōkyū*, points in the center of each palm.

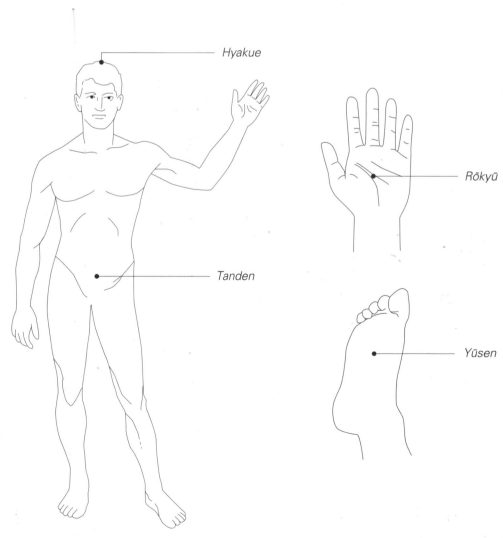

Hyakue

Rōkyū

Tanden

Yūsen

Yōki-hō is founded on the Nishino Breathing Method, a technique for activating the untapped energy of *ki* that was developed and popularized by the ballet teacher and student of Aikidō and Kung-fu Nishino Kōzō. Yōki-hō also incorporates the essence of a wide range of other disciplines, including:

- Jikyō-jutsu, a Japanese technique for maintaining health through physical and breathing exercises (created by Nakai Fusagorō);
- the Nishi Health System, an approach to maintaining health through diet, hot and cold baths, and physical and spiritual exercises;
- Hida Kyōken-jutsu, a method of strengthening the body and spirit (created by Hida Harumitsu);
- Makkō-hō, a system of six basic exercises that can be used as a form of preventive medicine and that work on physical as well as mental and emotional levels to enhance the flow of energy through the body (created by Nagai Wataru);
- Shintaidō, or New Body Way, an avant-garde martial art developed in Japan from karate and other traditional martial arts as a method to increase self-awareness and serenity (created by Aoki Hiroyuki);
- Jikishinkage-ryū, one of the major styles of sword fighting that emerged in the early Edo period (1600–1868) and that later was an important influence in the creation of modern kendō.

Yōki-hō also incorporates some aspects of the Chinese disciplines of Tai Ji Quan (T'ai Chi Ch'uan), Qi Gong (Ch'i Kung), and other Chinese martial arts. The principles of Indian yoga are another important influence, as are the Sati exercises created by J. Garre (1923–98), who taught the Buddhist teachings found in the Satipaṭṭhāna Sutta, the "four foundations of mindfulness."

Yōki-hō is essentially practice in loosening the joints to allow greater flexibility, drawing in the energy of heaven from the *hyakue* in the crown, pulling in the spiritual energy of the earth through the *yūsen* in the feet, and, with the *tanden* as center, letting the energy flow through the body unimpeded so that it may be directed at any time through the *rōkyū* in the hands. In the morning, the main purpose of Yōki-hō is to invigorate the senses, while in the evening the focus is on purging the body of bad influences.

Yōki-hō: The Long Version

The long version of Yōki-hō takes about thirty minutes. Throughout this warm-up exercise, your movements should be slow and fluid, your breathing calm and even. Combine Yōki-hō practice with WARM-UP EXERCISE 3, *if desired. When your time is limited or if you simply prefer a faster warm-up, see the five-minute Yōhi-hō in* WARM-UP EXERCISE 2.

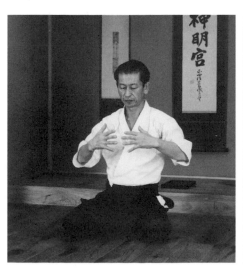

1 Assume a kneeling position. While exhaling, stretch and bend forward to assume a position of full prostration as shown.

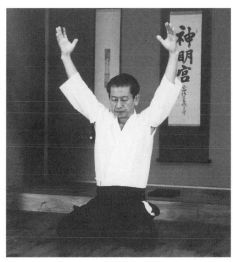

2 Return to the kneeling position, then reach up to take in the *ki* of heaven through your hands.

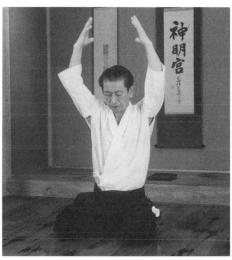

3 Sense the connection between the *rōkyū* in the palms of your hands and the *hyakue* on the crown of your head.

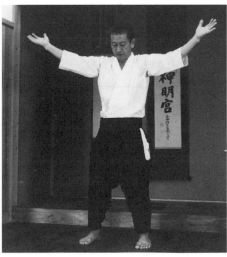

4 Lower your arms, moving them past your chest (as shown), to a point in front of your *tanden*, located just below and behind your navel.

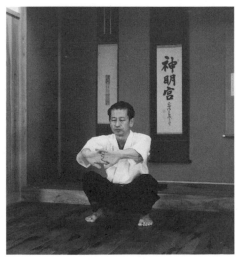

5 Stand and spread *ki* from your *tanden* in all directions.

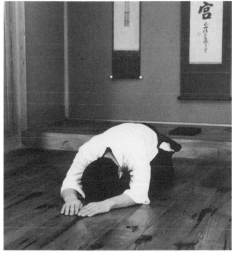

6 Sink down in a crouch while exhaling and discharge *ki* from your *tanden* through the *rōkyū* in your palms.

27

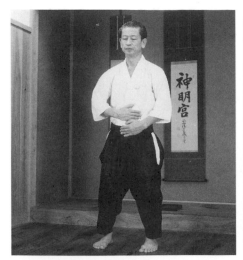

7 Spread *ki* to your abdominal area.

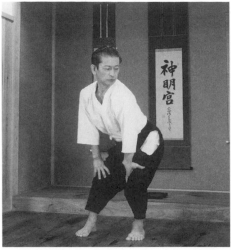

8 Release the tension in your upper body and let your strength fill your lower body, shifting your hips back and forth several times.

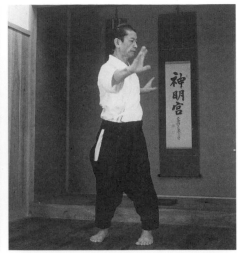

9 Rotate the upper body—first to the left and then to the right—while exhaling and inhaling, positioning your hands as shown.

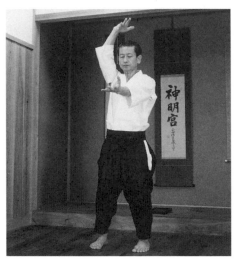

10 While exhaling and repositioning your hands, release tension from your internal organs.

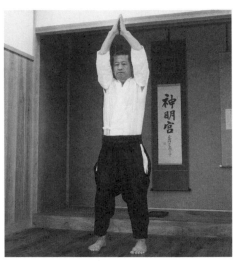

11 When you have exhaled completely, bring your palms together above your head, pulling up your internal organs.

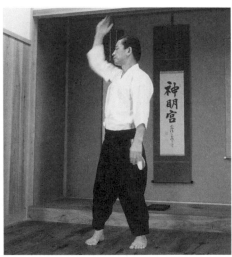

12 With your hands still raised, rotate your upper body to the left and right several times, and when you feel the weight of your hands, let them fall naturally to your side.

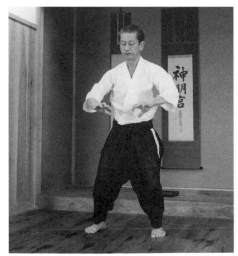

13 Inhale, and then while exhaling, imagine that you are opening heavy iron doors from your *tanden*. When the doors have opened to their limit, let the energy flow explosively from the *rōkyū* in your palms.

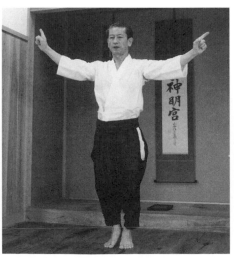

14 Raise your arms and rotate your upper torso in a circular motion from the hips several times. This circle is an *ensō*, or Zen circle.

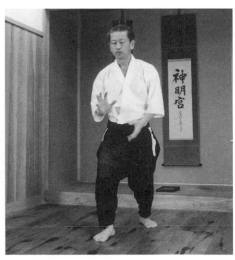

15 Pull the earth's energy from the *yūsen* on the soles of your feet to your *tanden* and then project this energy from the *rōkyū* of your right palm.

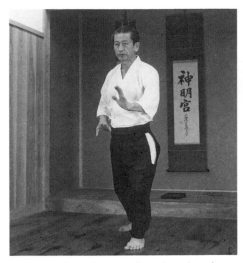

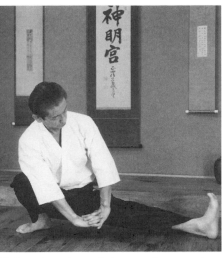

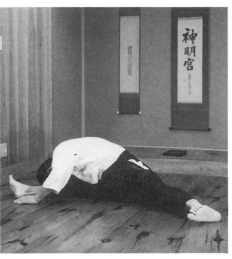

16 Now project this energy from the *rōkyū* of your left palm and send it far off, into infinity.

17 Stretch as shown, lacing your fingers and extending each leg with the sole of the foot facing outward, perpendicular to the floor.

18 Stretch as shown, first to the left and then to the right, loosening both sides of your body.

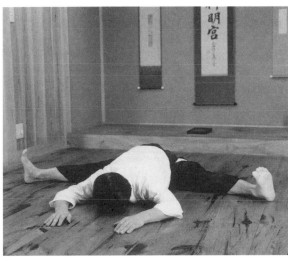

19 Fully stretch and loosen your upper body.

20 To exercise your eyes, alternate between focusing first on the forefinger of your left hand and then on the forefinger of your right hand, for one second at a time. Repeat several times.

WARM-UP EXERCISE 2

The Short Form of Yōki-hō: A Five-Minute Exercise

This shortened version of Yōki-hō is based on the form and philosophy of the "five expressions of heavenly truth" in Shintaidō. When little time is available before calligraphy practice, this shortened version can be performed in a seated position in as little as five minutes, as follows:

· First, perform a full prostration as shown in step 1 of the long version.
· After returning to a kneeling position, focus on the *tanden*, the center of your body located slightly below and behind the navel and begin to exhale.

While exhaling, release the tension in your body, starting from your *tanden* and spreading outward, until finally the tension is expelled from your body.

· Then, concentrating on both the *tanden* and the *rōkyū* points in your palms, let *ki* energy fill your *tanden* while raising both hands up high toward heaven.

· Sit in meditation and imagine an egg-sized lump of medicinal balm resting on the crown of your head, at your *hyakue*. Envisage the heat of your body gradually melting this balm, allowing its medicine to flow through your body, washing away all poisons with it. The balm flows from your head, through your neck, down to your chest, through your stomach, your hips, and legs, and is finally expelled from the *yūsen* points at the soles of your feet. (This method of visualizing the flow of medicine is based on a method developed by the eighteenth-century Zen master Hakuin.)

· Next, draw the *reiki* (spiritual energy) of the earth up toward your *tanden* to fill the center of your body. Spread your hands and direct this energy out into space. Then, let the energy of heaven converge at your *tanden*, and again scatter to an infinite distance from your *rōkyū*.

· If possible, continue this exercise for several minutes.

WARM-UP EXERCISE 3

Kūsho: Writing in the Air

It is said that the Buddhist patriarch Kūkai used to write calligraphy in the air. After using either the short or the long version of Yōki-hō to release tension from the body, try writing in the air with one arm. Choose an image or a character in grass script, such as the character *mu*, meaning "nothing," (see EXERCISE 7). Trace your chosen image in the air as if your hand and arm were the brush. Write freely and easily, moving with abandon.

Now plant each foot firmly on the ground as if roots were spreading out from your feet and into the earth. This time imagine writing the character as if your whole body were a brush. Let your upper body move freely and pliantly, in broad sweeps. Write with your whole mind and body. Take it still further by closing your eyes and writing without your hands, allowing your body to sway as you trace the image. Try this with both arms raised and then again with your arms at your side. Finally, try writing in the air in any way that feels right to you.

This is a very effective method of reinforcing the idea that the whole body is used in calligraphy.

ZEN CALLIGRAPHY
AND PAINTING

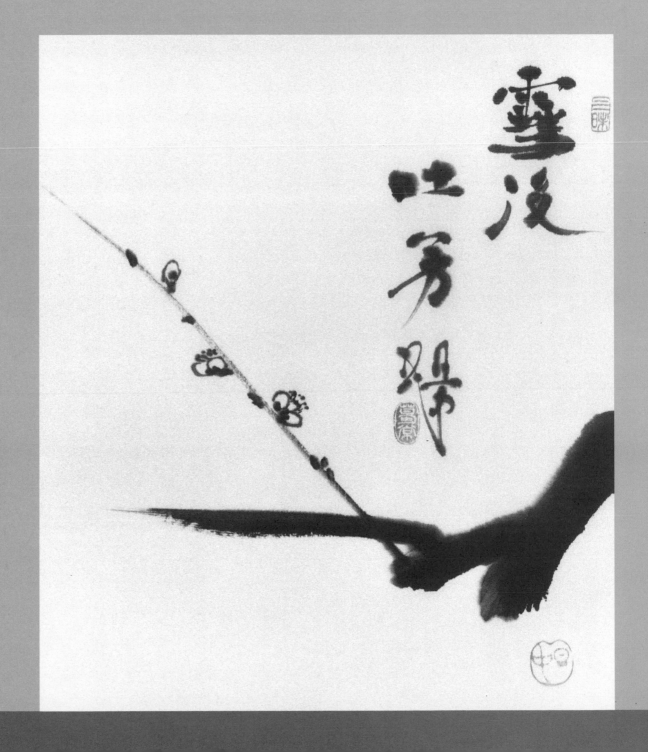

Basic Practice

The Zen Line and Its Applications

EXERCISE 1

Mujibō (The Zen Line)

This line, which slices heaven and earth into two perfect halves, is drawn by first eliminating the self. Drawing this line takes all the power that the mind and body possess, and it can therefore be called the basis of Hitsuzendō.

 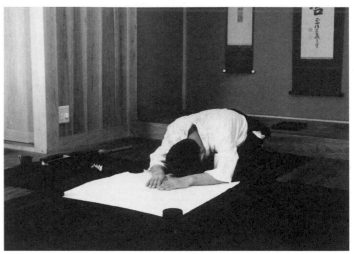

1 Fully charge the brush with ink. Shed just enough ink into the *suzuri* (inkstone) to keep excess ink from dripping off the brush.

2 Bow deeply, breathing out, and clear your mind.

Holding the Brush

3 Lift the inked brush with your right hand, then lightly grab the shaft near the bristles with the thumb and index finger of your left hand. Next, firmly grasp the brush in your right hand with your fingertips surrounding the shaft just above the bristles of the brush. Hold the shaft principally between your thumb and middle finger, with the other fingers adding gentle support.

4 Taking a deep breath, erase all other thoughts from your mind as you raise the brush.

NOTE: Follow this procedure for the first piece of calligraphy you brush in each session. For the remaining pieces, follow steps 1 through 3 in EXERCISE 2.

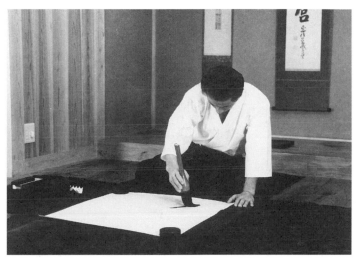

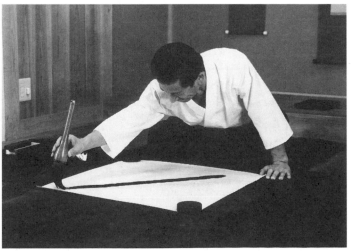

5 Raise the brush as high as you can just as you finish drawing in breath. Let your *ki* drop to your *tanden*. Enter the state of *konton-kaiki*, the primordial void that exists before creation. In Zen, this state of vital repose contains everything. Out of the chaos of images and thoughts in *konton*, a vivid image will emerge. Just as that image *begins* to manifest, your brush should start its journey.

6 Hold down the paper with your left hand and let the brush descend slowly and softly. Begin the stroke with the brush first moving in the direction opposite that of the stroke. This is called *gyakunyū zōhō*, or "entering from the opposite direction to conceal the beginning [of the stroke]." Apply pressure to the brush and begin the stroke, moving in the opposite direction intended, then reverse your direction and brush over your starting point as shown here.

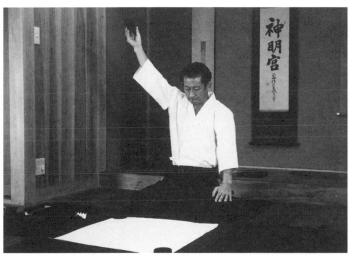

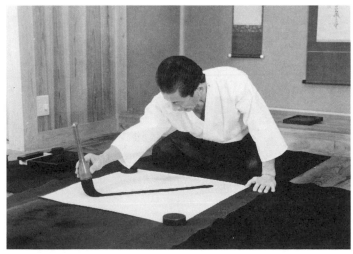

7 As you move the brush, focus all the power of your mind and body on drawing the brush handle forward, as if you were pulling a heavy stone on a rope, exhaling slowly with the advance of the brush. Use the midsection of your thumb to twist the brush inward as necessary so that the center of the brush tip travels along the center of the line.

8 Keep your spirit in the stroke even after the brush leaves the paper. The movement continues on and on, returning to the primordial void from which it emerged.

Ensō (The Zen Circle)

Our original spirit is free and infinite in scale. The Zen circle can be thought of as a symbol of this original spirit. Creating an ensō calls for nothing more than drawing a circle—something anyone should be able to accomplish with ease. However, if our spirit is not open, if we are not awakened to our infinite mind, or if we are captive to the extraneous cares of our everyday lives, we will find it hard to brush a circle expressive of true freedom.

A Zen circle that is serene like the autumn moon may be beautiful to look at, but the true ensō dares us to take chances—it should be grand and blazing with energy like the morning sun.

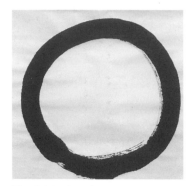

The finished work.

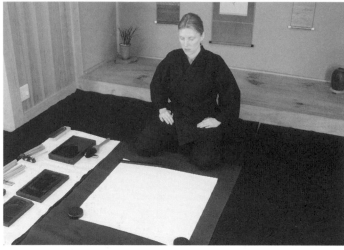

1 Focus your *ki* at your *tanden* but remain absorbed for a time in the void as the image forms.

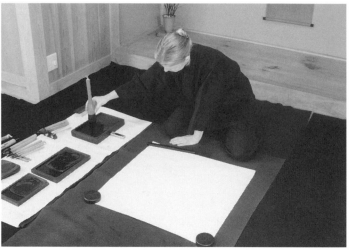

2 Fully charge your brush with ink.

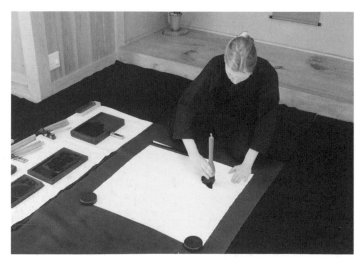

3 As with the Zen line, let the brush descend naturally and slowly. Again, begin the stroke with the brush tip moving in the direction opposite that of the stroke (see EXERCISE 1, step 6). Reverse direction so that the brush tip turns back, and begin to brush from the lower left corner of the paper, concentrating all the power of your mind and body on your stroke.

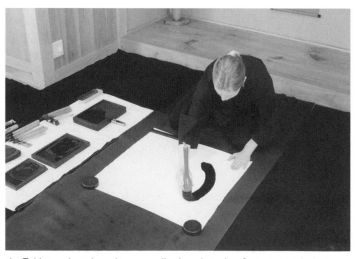

4 Taking a deep breath, erase all other thoughts from your mind as you continue the stroke.

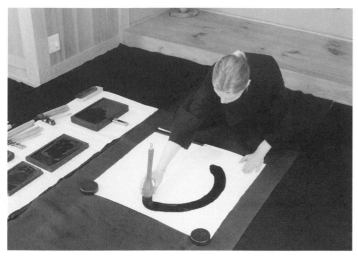

5 Continue slowly and calmly, keeping the shaft of the brush vertical.

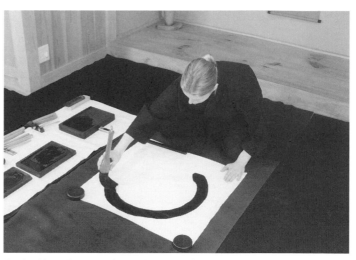

6 At this point, use the midsection of your thumb to twist the brush inward.

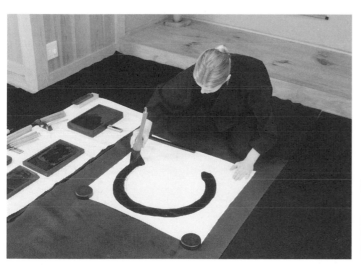

7 Keep the brush vertical as you proceed with the stroke.

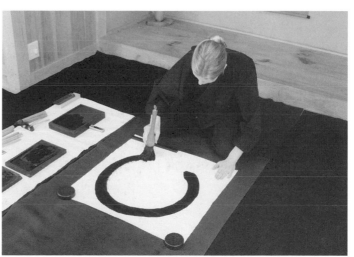

8 Continue to focus all the power of your mind and body to prevent the lower right portion of the stroke from weakening.

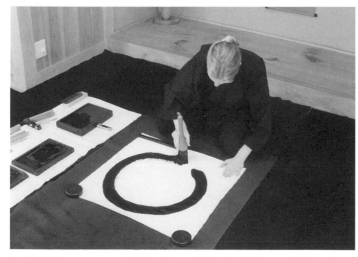

9 Maintain your concentration. Be careful not to let the end of the stroke become too light.

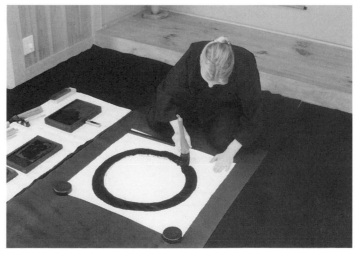

10 Even after completing the circle, keep your spirit concentrated as you withdraw the brush from the paper and return to the state of primordial void.

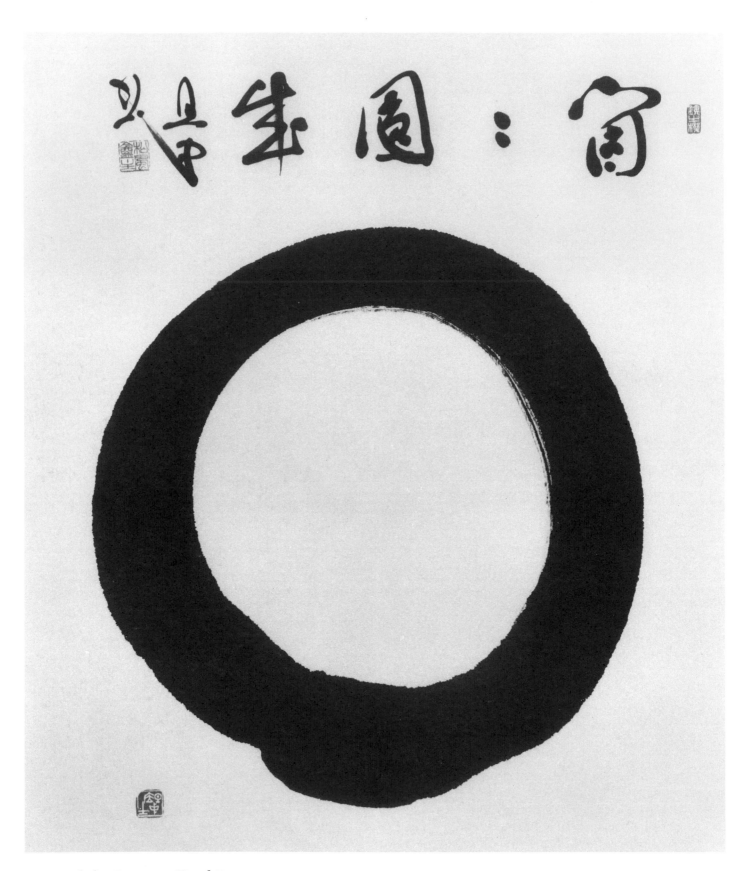

Zen Circle by Terayama Tanchū
Koko enjō 箇々圓成
INSCRIPTION: *Each thing is perfect.*

30 x 24 *inches* (77 x 61 *cm*)

Horizontal and Vertical Lines

The Zen line, being a single stroke, lends itself to total concentration. The following exercises require you to draw a series of lines. Rather than focusing on a single line, the key point in EXERCISES *3 and 4 is to always stay in the moment. In other words, do not let yourself be distracted by your surroundings or extraneous thoughts. Focus exclusively on what you are brushing in the instant you are brushing it.*

1 Begin at the top right-hand corner of the page.

2 Draw the brush across the paper without haste or hesitation, following the steps for brushing the Zen line in EXERCISE 1. Let the power of your stroke flow from your *tanden*.

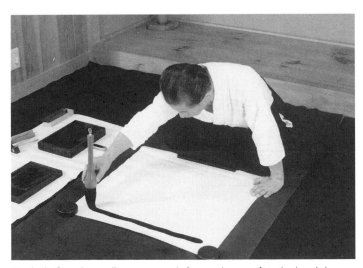

3 As before, keep all your strength focused even after the brush leaves the paper.

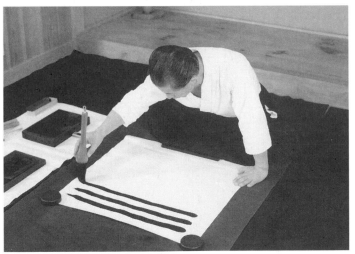

4 When brushing a number of lines, you may easily be distracted by the other lines or the emerging group you are brushing. Discard these thoughts. In order to express vitality in each line you must stay focused on what you are doing. The key point is to stay focused, concentrating exclusively on the line you are brushing.

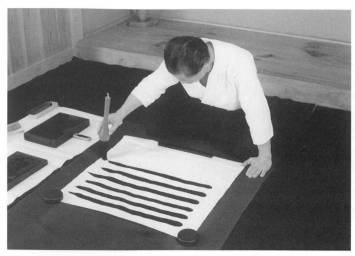

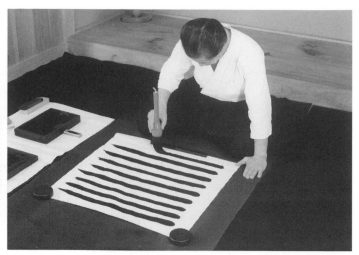

5　Even while focusing your mind and body on what you are brushing, do not lose sight of the whole.

6　Keep your strength and mind focused until you complete the final horizontal stroke.

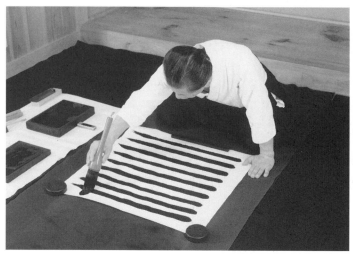

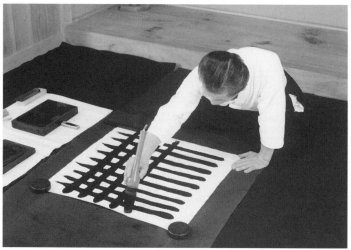

7　The same points hold true when brushing vertical strokes. When brushing vertically you will find that your upper body bends with each stroke. Your body should move with your progress toward the lower edge of the paper.

8　Continue to focus without allowing yourself to be distracted by the strokes that you have already drawn. This is a way to attain single-mindedness.

9　Draw the final stroke while continuing to use the power of your *tanden*, then return the brush to the state of primordial void.

Fine Lines

As in EXERCISE 3, *focus your concentration and stay in the moment.*

1 In this exercise, use a fine brush to draw thin lines. Again, adhere to the same principles as when brushing the Zen line (EXERCISE 1) and the series of practice lines (EXERCISE 3).

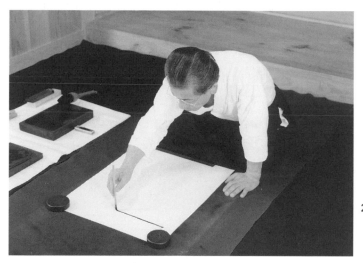

2 Keep your hands flexible without putting your strength in your fingers. Let the power for the strokes flow from your *tanden*.

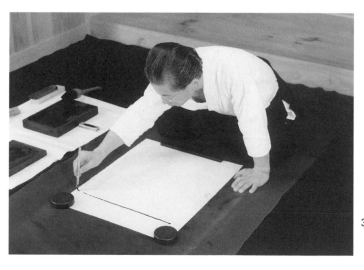

3 As before, keep your energy focused even after the brush is withdrawn from the paper.

TENSHO (SEAL SCRIPT)

Sō (Grass) and a Practice Line

Seal script was developed as the official Chinese writing style in the third century B.C. Today, it is most frequently seen on the stone seals used for official documents or works of art. Being closer in form to the original pictographs, seal script reveals recognizable forms.

In seal script, the initial point where the brush touches the paper is concealed within the stroke and often the end of the stroke is rounded off. Seal script is essentially constructed from a succession of Zen lines with rounded ends.

The kanji for "grass" brushed in this exercise is a pictograph representing shoots emerging from a seed. Keep this image in mind as you practice this character.

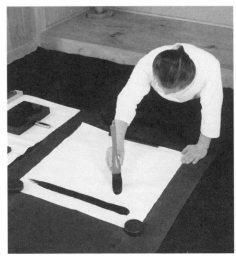

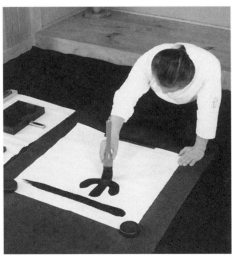

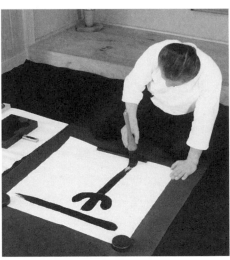

1 Draw a single horizontal Zen line (see EXERCISE 1).

2 Next, as an application of the Zen line, try brushing the *kanji sō* (草) for "grass" in *tensho* (seal script) style. Draw the shallow "U" shape first.

3 When brushing the vertical strokes in particular, you must write with your entire body or the brush may tilt and the strokes will lack vitality.

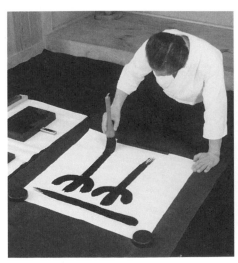

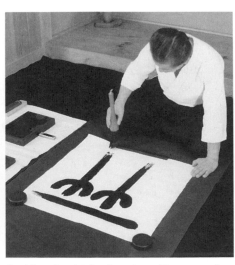

4 In seal script, the forms of *kanji* favor a straightforward vertical and horizontal symmetry.

5 All seal script *kanji* can be written as applications of the Zen line.

KAISHO (STANDARD SCRIPT)

Sho (Calligraphy) and Practice Lines

In standard script, each dot and stroke is arranged in careful order without any linking of strokes. This writing style is the basis for the printed type now used in books and newspapers.

When brushing a horizontal stroke, begin with the shaft of the brush tilted forty-five degrees in the opposite direction (so that the brush tip reverses direction when you change the direction of the brush) and proceed through the stroke with the brush tip tracing the center of the stroke. Use pressure from the inner side of the thumb to twist the brush inward while keeping the shaft vertical. At the end of the stroke, press the brush down slightly, and then pull the brush away so that the brush tip leaves the surface at the lowest end of the stroke. These are the principles for brushing the character ichi (一), *or "one." Sho* (書), *"calligraphy" or "writing," is constructed from a succession of these horizontal* ichi *strokes, and the principles for brushing vertical strokes are the same.*

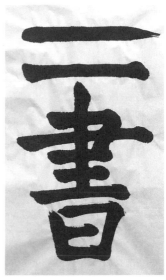

The completed piece.

1 First, draw the Zen line of EXERCISE 1 across the top of the paper. Next, we will apply the principles used in the Zen line to write the character *ichi* (一) for "one." Draw a second line. Use the midsection of your thumb to twist the brush inward as necessary so that the brush tip travels along the center of the line.

2 End the stroke by increasing pressure on the brush and then lifting it from the sheet to end the line with a solid finish (see completed piece above). Remember to write with your whole body, using power that originates from the hip area and the *tanden*.

3 Withdraw the brush tip from the lower right side of the line. This brush technique both trims the shape of the stroke and rearranges the bristles of the brush itself, readying them for the next stroke.

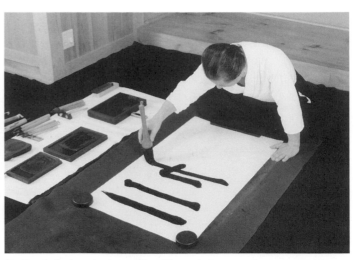

4 Now use the method for brushing the character "one" to produce the character *sho*. Brush a short horizontal line at the top, then continue the stroke without lifting the brush and finish with a vertical line. Check the completed piece on the previous page for proportions.

5 Brush the long horizontal line. The technique used to write the character for "one" can be applied to all of the strokes of this character. The key point is to keep the brush tip "shaped" (as described in step 3) and vital throughout the course of each stroke.

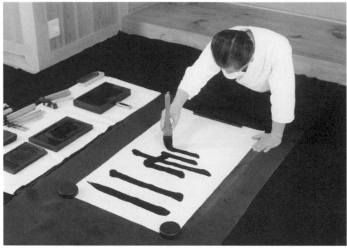

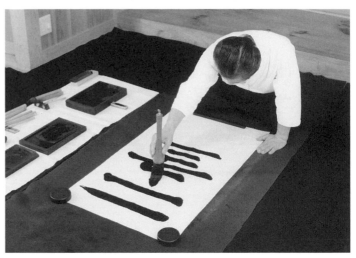

6 Write the third, fourth, and fifth horizontal lines, following the proportions shown in the completed piece. Brush each and every stroke with care, but never let your movement stop. The brush must be kept moving.

7 Brush the central vertical line. The principles for brushing the vertical strokes are the same as for the horizontal strokes.

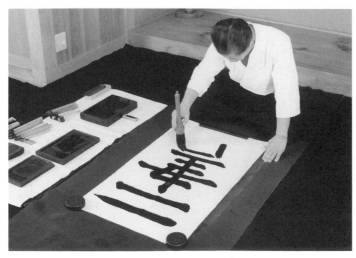

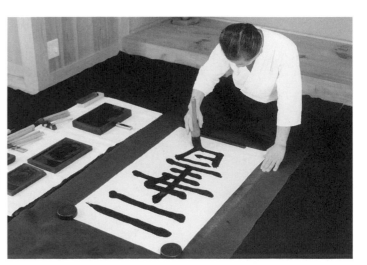

8 After the top portion of the character *sho* is finished, begin the bottom square. Brush the vertical line at the left, then brush the top and right-side of the square, echoing the horizontal-and-vertical stroke of step 4.

9 Finish the character by drawing the center and bottom lines of the square. Keep your *ki* focused to the last stroke.

Further Practice

SŌSHO (GRASS SCRIPT)

Grass script tests the limits of simplification—it is a writing style that stops one small step short of total illegibility. Since this writing style is formed almost entirely of cursive strokes, it should be brushed like a snake swimming through water—gently and flexibly and as an expression of one's entire mind and body

EXERCISE 7

Mu (Nothing)

The character mu (無) *for "nothing" is often featured in calligraphy. Examples of this character appear in* EXERCISE 10, *in the pictures of Daruma on pages 18 and 67, and, in an entirely different style, in the center of* Sankō mu kokon *on page 92.*

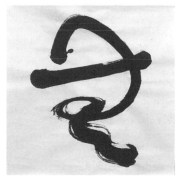

The completed piece.

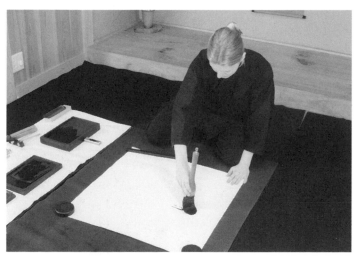

1 Take a deep breath, let your *ki* settle at your *tanden*, ink your brush, and begin the stroke from the state of primordial void, following steps 1 through 3 of EXERCISE 2.

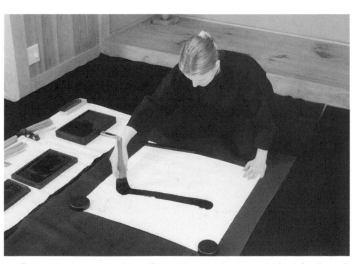

2 Draw a horizontal stroke as if brushing the character *ichi* (一) for "one," as explained in EXERCISE 6, steps 1 through 3.

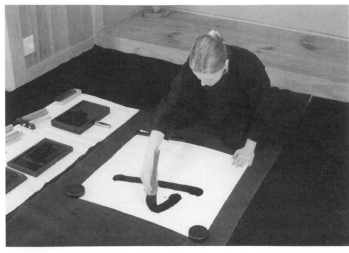

3 Begin the next stroke with total concentration, just as a martial artist focuses his or her energy with a sharp cry when striking.

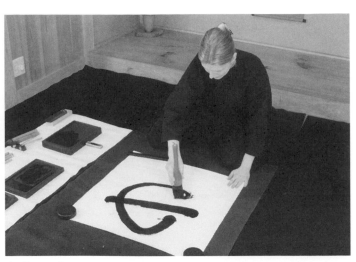

4 Draw a large arc.

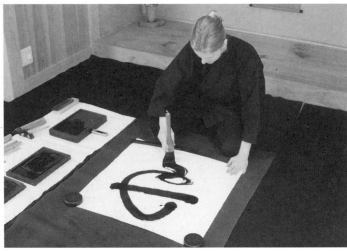

5 Move the brush ahead fluidly and energetically, finishing the arc and brushing a loop.

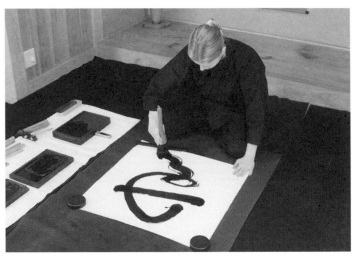

6 Move your body together with the brush, in the same way that a snake swims through water, and finish the "tail" of the character.

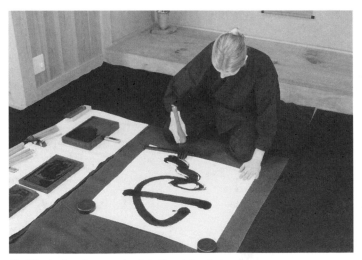

7 Lift the brush, returning it to the state of chaos.

Hana (Flower) 花

The character for "flower" may simply denote a flower that blooms and then dies and scatters its petals, but the figurative flower of the Nō playwright Zeami (1363–1443), makoto no hana, is more than this: it is the flower of the heart that blooms when we polish our skills. Opposed to this image is kūge, the illusory flower of vanity. When we brush the kanji for flower, we cannot let ourselves be drawn astray by extraneous thoughts.

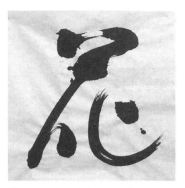

The completed character *hana*.

1 Focusing your *ki*, bring your brush to the paper in one deliberate movement.

2 Pull up slightly to let the tip of the brush come to the end of the stroke.

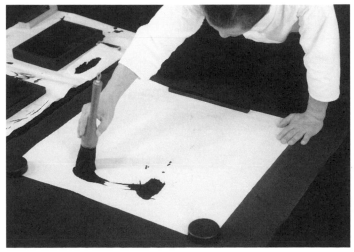

3 Move across to the next point of the character.

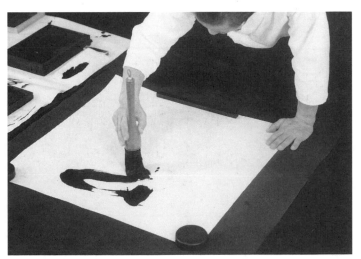

4 Complete the top portion (⺌).

45

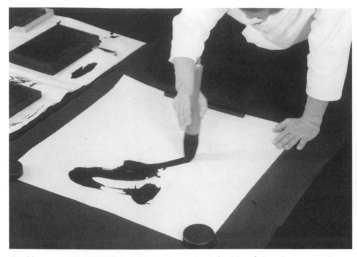

5 Next, move on to the element 人 on the left side of the character, drawing the long stroke . . .

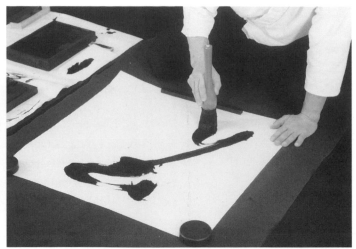

6 . . . and finishing with the short stroke.

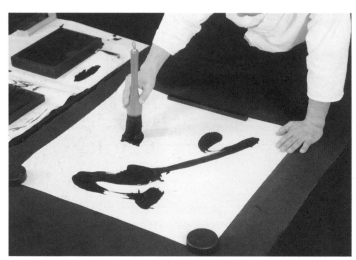

7 Brush the final element 匕. Start with the dot . . .

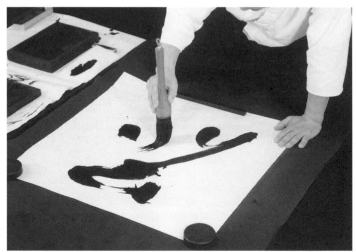

8 . . . and finish with the swooping curve.

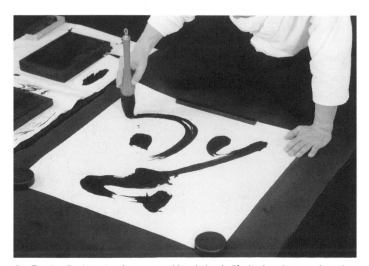

9 For the final stroke, focus your *ki* and slowly lift the brush to again arrive at *konton*, the state of chaos.

Kū (Emptiness) 空

The kanji *for "emptiness" was used to translate the Sanskrit word* sunya, *which refers to something that, though large or swollen, is hollow inside. In* The Book of Five Rings, *Miyamoto Musashi stated that "true emptiness is total awareness of everything without being trapped by this awareness."*

Total awareness calls for maximum effort. Remaining totally free from entrapment calls for unrelenting practice and training.

Having achieved total awareness and freedom from distraction, we cast all aside, and then, in an absolutely pristine state, we take up the brush. The character that results is fresh, original, and limitless.

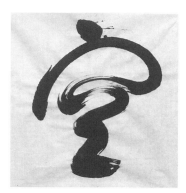

The completed character *kū*.

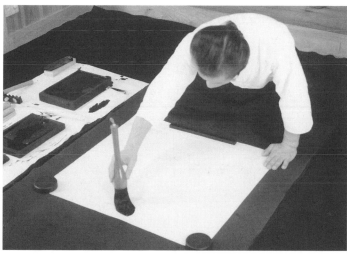

1 Begin the stroke as your image emerges from the primordial void, bringing the brush tip gently into contact with the paper.

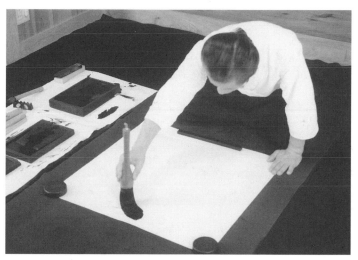

2 Form a dot.

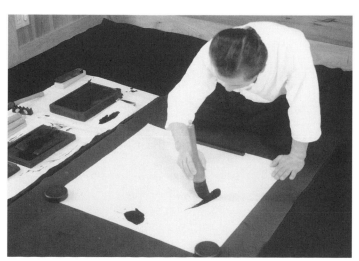

3 Begin the crown of the character, brushing down and then up.

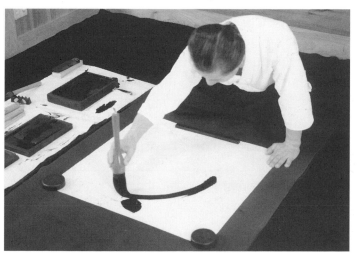

4 Proceed through the stroke of the crown, forming a large arc.

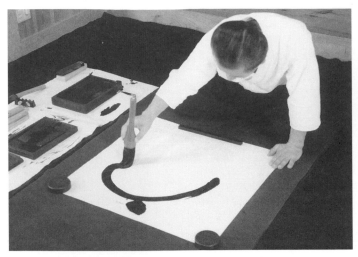

5 Bring the brush around and under to form a second arc, . . .

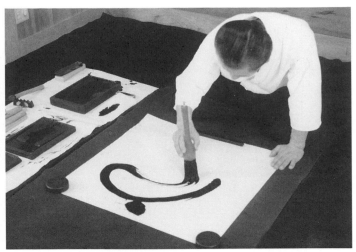

6 . . . letting the brush dance as you begin the downward swirl.

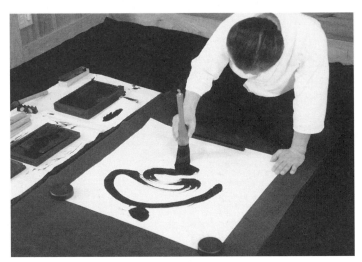

7 Proceed to the final stage of the character, keeping your movements fluid.

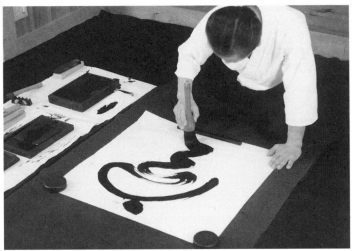

8 Keep an eye on the overall balance of the character as you proceed.

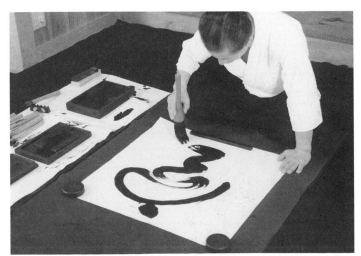

9 Maintain your focus as you lift the brush and finish your work. Do not allow your *ki* to waver or lose focus until after the brush leaves the surface of the paper and returns to *konton*, the state of primordial void.

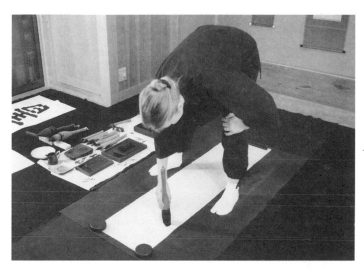

The completed calligraphy.

Mu Ichi Motsu (Owning No-thing)　無一物

In this and the following exercise, we will practice a series of characters that brings together many of the techniques illustrated in earlier examples. This phrase is a key Zen expression: abandon all possessions—material, psychological, and spiritual—in order to realize true liberation.

1　Write while straddling a long sheet of calligraphy paper (*gasenshi hansetsu*), keeping your knees loose and flexible and letting your *ki* drop to the soles of your feet. Release the tension from your upper body and let your strength find its source at your *tanden*.

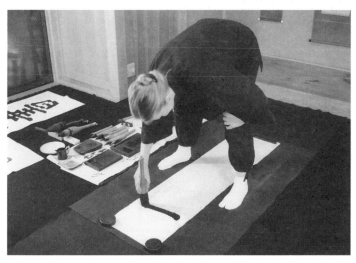

2　The essentials of writing are precisely the same whether seated or standing, but when working with a large piece of paper you will be able to move more freely if you work from a standing position as shown. The first character, *mu*, was brushed in EXERCISE 7. Write the first stroke, . . .

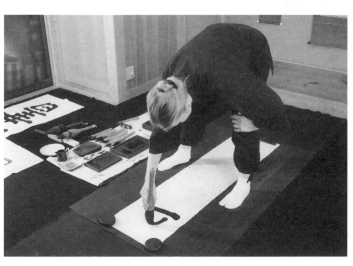

3　. . . then begin the arc, keeping the brush vertical, as shown.

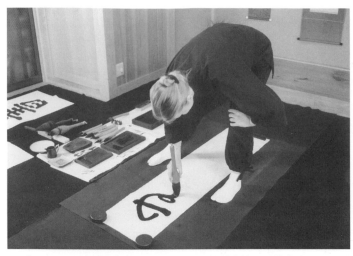

4 Continue with the loop and begin the "tail." You will find a natural rhythm to the pace of writing, but be careful not to let the brush stop when moving slowly, or skip when moving quickly. From beginning to end, keep your concentration constant and unbroken.

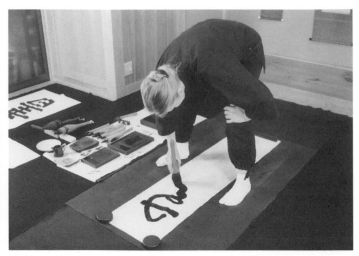

5 Finish the character. Move the brush with your whole body, even for the smallest strokes.

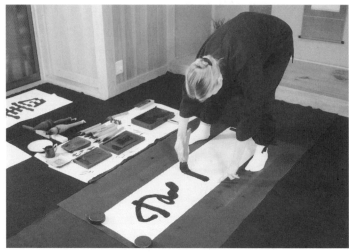

6 Keep your *ki* focused when moving to the next character, *ichi* ("one"), to prevent any discontinuity in your *ki* from character to character. Brush this character as explained in steps 1 through 3 of EXERCISE 6.

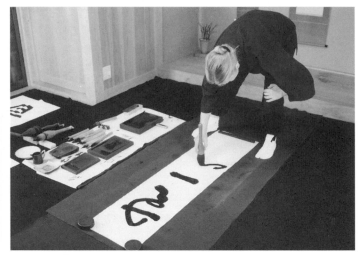

7 Brush the third character, beginning with the loop at the left . . .

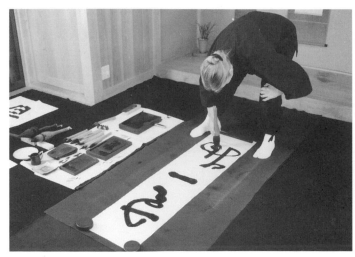

8 . . . and continue with the vertical and cross strokes and the final loop. Whether the line is long or short, do not vary the power of your stroke. Complete the final character without a break in concentration.

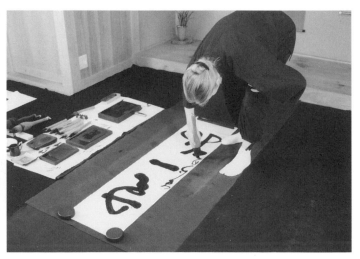

9 The practitioner adds her signature along the far left. Even when writing these much smaller characters, continue to wield the brush with all your strength.

Ichigyō Zanmai (Be in the Moment) 一行三昧

Ichigyō zanmai is total immersion in a single act. When writing ichi (一), *focus only on* ichi; *when writing* gyō (行), *focus only on* gyō. *To do this, invest body and soul in the task before you—this you must never forget. Become one with the brush. Becoming one with the brush means forgetting the brush. The key is to study meticulously and practice relentlessly.*

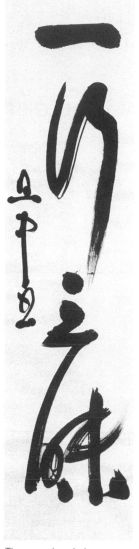

The completed piece.

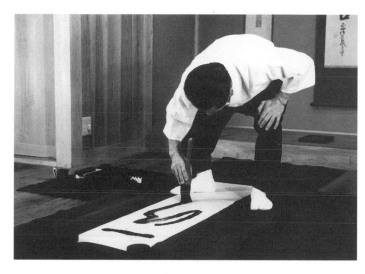

1 Now try the series of characters on your own, using the finished piece as guidance.

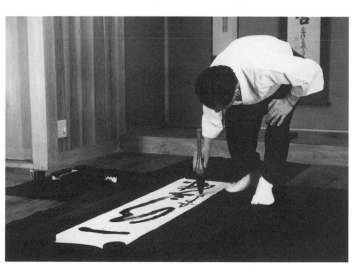

2 Add your signature in a stylized fashion at the far left, either in *kanji*, if you have a *kanji* name, or in a vertical flowing rendition of your name in the Western alphabet. Practice your signature beforehand. See EXERCISES 12 and 13 for calligraphy using Western letters.

Writing Western Script: ABC

When writing letters of the Western alphabet, the essentials are exactly the same as when writing kanji. *The Western alphabet offers fewer opportunities for varying shapes, but the lines should be brushed with the same principles in mind.*

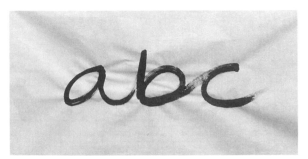

The completed piece.

1 Begin the stroke lightly with the brush moving in the direction opposite that of the stroke (see EXERCISE 1, step 6).

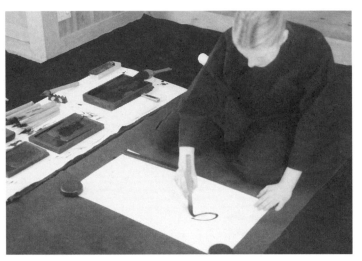

2 Although Western letters may lack variation in the thickness of lines, the potential for expression is still limitless.

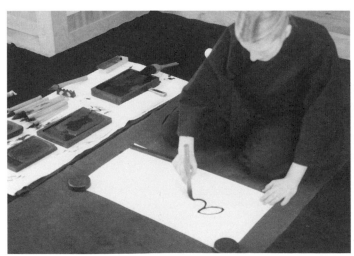

3 Different expressive qualities can be given to the lines connecting characters.

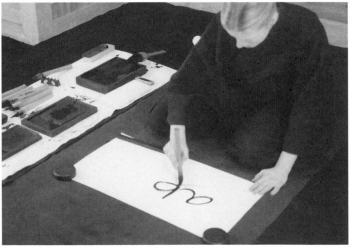

4 Practice and experiment to expand your range of expression. Hold the brush as flexibly as possible to allow full expression of each delicate movement of your fingers.

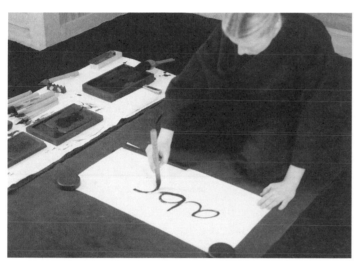

5　You will find that the tip of the thumb plays the chief role in subtly manipulating the brush.

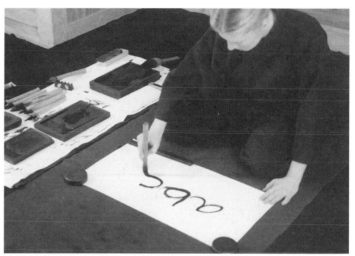

6　The linking stroke may become weak as the ink is exhausted, but the next solid line is again full and rich with ink.

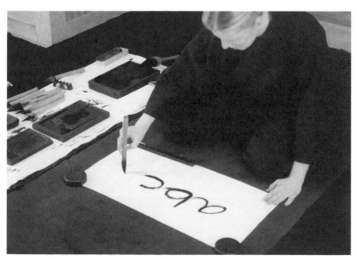

7　As with previous exercises, maintain full concentration from beginning to end.

Shodō (Calligraphy)

Although students in the West often remark that kanji *hold greater mystery than the characters of their own writing system, I feel that the calligrapher using the Western alphabet is equally capable of expressing beauty of line and the perfection of form. D. T. Suzuki (1870–1966) wrote in English with a brush, and his work reveals depth and purity. The signatures of many artists and creative people—Rodin and Matisse come immediately to mind—are equally beautiful. Although I still lack the experience to produce work that compares with these masters, I continue to study their efforts so that through practice and experimentation I might someday approach their level.*

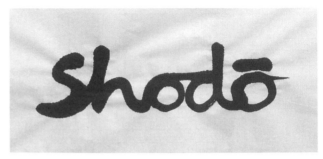

The completed piece.

1 We will practice writing the word *shodō* in the Western alphabet. Before you take up the brush, an image of the completed work should be set at your *tanden*, or center.

2 Your ability to express the image in your mind on paper without distraction is evidence of your success.

3 In this task concentrate on becoming one with the brush.

4 Since heart and brush are both alive, no two works will ever be exactly alike, no matter how many times you write them. Unlike mass-produced products, calligraphic art work has a vitality all its own.

5 Though each letter is separate, they are linked as if sharing one life. As with calligraphy using Japanese words, you have a chance to create a work of subtle power. Strive to create a piece of calligraphy with charm, beauty, and a harmonious composition.

Painting

Orchid

The techniques used in calligraphy also lend themselves to rendering images in sumi *ink, and an orchid is an admirable subject for an ink painting. An ink painting usually begins by first charging a clean brush with water and then adding a small amount of* aozumi, *a blue-black ink that contains a blue pigment (indigo) to produce an extremely deep black. However, in the beginning regular* sumi *ink will suffice.*

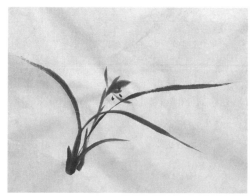

The completed painting.

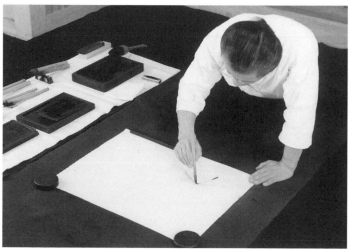

1 Begin the stroke from the opposite direction in the usual manner. At the beginning of the line, restrain the power of the stroke to produce a thin line.

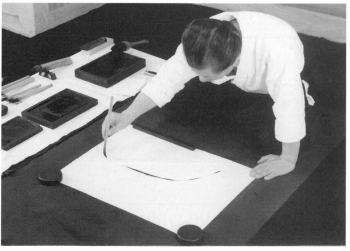

2 In the middle of the stroke, apply a little more pressure to the brush to make the leaf thicker, then ease the pressure, making the leaf narrower. Stay focused even as you withdraw the brush from the paper.

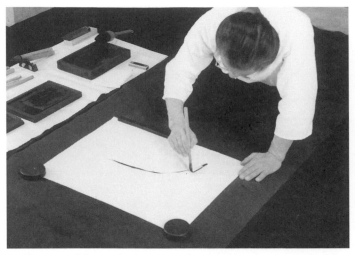

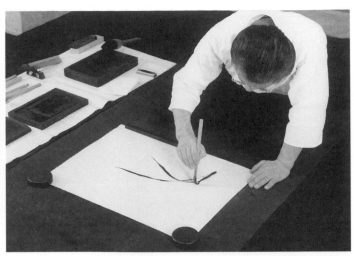

3 The essentials remain the same when brushing the second leaf, but take care that the second leaf does not run parallel to the first. Introduce slight variations in the stroke to create a different leaf.

4 Again, introduce variations for the third leaf in the same way as for the second, but don't allow the base of the orchid to become too thick. The third leaf should be brushed to the left.

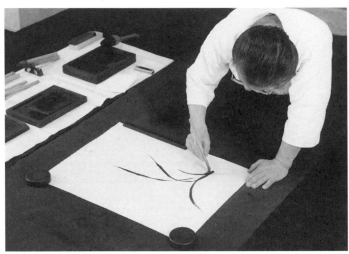

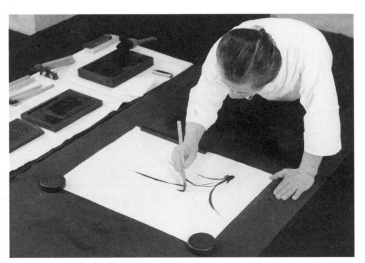

5 The fourth leaf is brushed from the tip of the leaf toward the root. Brushing in this direction also serves to realign the bristles for the next strokes.

6 In the same manner, add a small shoot to the left of the first leaf, and then proceed to the flower itself.

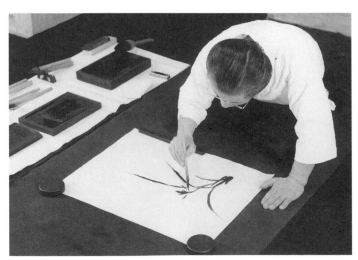

7 For the orchid flower, brush five strokes from the tip toward the center using weaker ink, and then add the stamens of the flower with thick ink by approximating three of the four strokes for the character *kokoro* (心), or "heart," in grass script. See the chart on page 12 for reference.

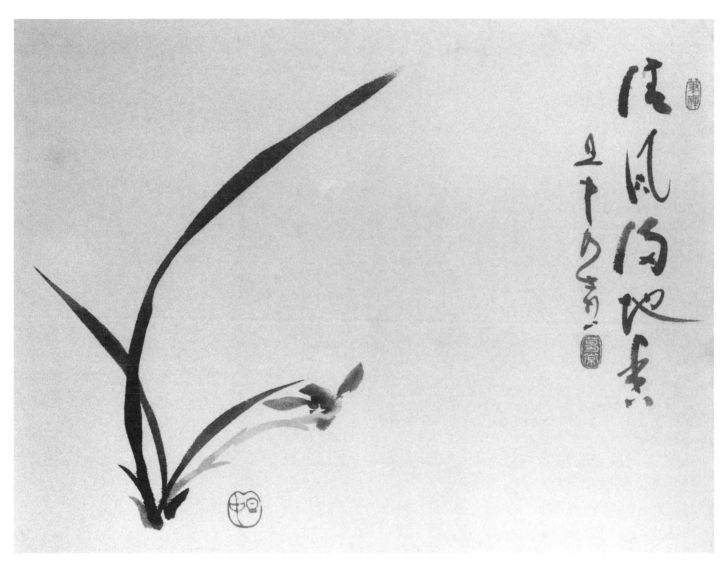

Orchid by Terayama Tanchū

INSCRIPTION: *Where fresh winds fill the earth, fragrance.*

Seifū manchi kō [Seifū chi ni michite kanbashi.]

清風満地香 [清風　地に満ちて香ばし]

11 x 15 *inches* (29 x 39 *cm*)

Bamboo

According to the traditions of China, where painting and calligraphy were considered as one, orchid, bamboo, plum blossoms, and chrysanthemum were known as the "Four Gentlemen." Bamboo is the logical first subject for a painting because it calls for a different brush style for each of its elements: the shafts are composed according to the rules of seal script, the branches follow the rules of grass script, while the leaves are based on the methods of scribe's script. We want to paint bamboo with stalks that are clear-cut but empty at their heart, branches that are taut and direct, and leaves that rustle in a fresh breeze.

Start with a careful observation of actual bamboo. Then, borrowing from the bamboo itself, try to express the direct and unpretentious nature of bamboo. Accomplishing this takes practice and experimentation.

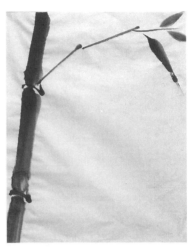

The completed painting.

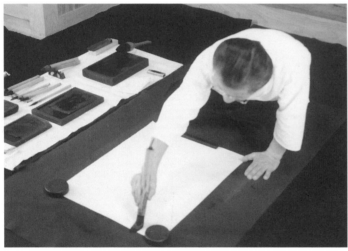

1 Brush the thick stalk of bamboo starting from the top with a strong, deliberate stroke.

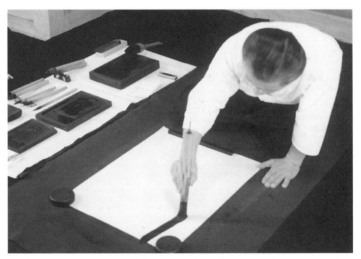

2 Since the upper portion of the stalk should be somewhat narrower than the lower portion, restrain your power slightly when starting the stroke.

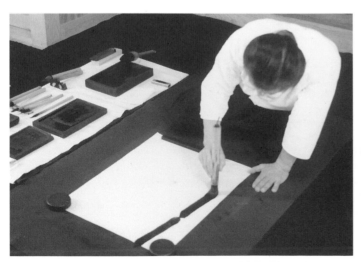

3 The second section of bamboo should be slightly thicker. Introduce breaks at the joints without breaking the continuity of the line.

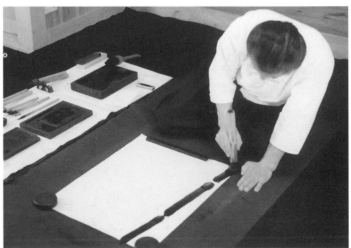

4 The third stalk of bamboo should be thicker than the second.

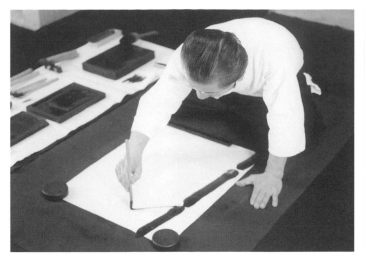

5　Switch to a thin brush to add the branches.

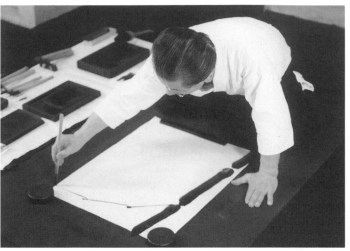

6　The smaller bamboo branches are relatively straight but have a graceful sweep.

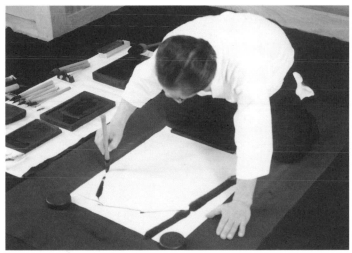

7　Add the leaves with a medium brush. Brush the most prominent leaf first.

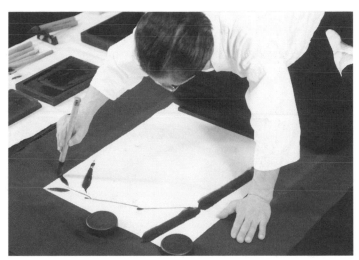

8　Brush in a few more leaves, taking care not to let them run parallel.

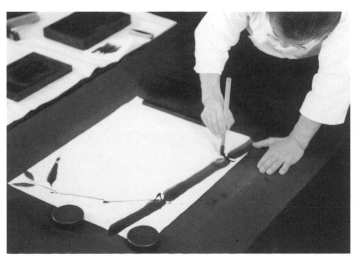

9　Check to see that the ink strokes have dried sufficiently, then brush in solid lines to represent the bamboo nodes.

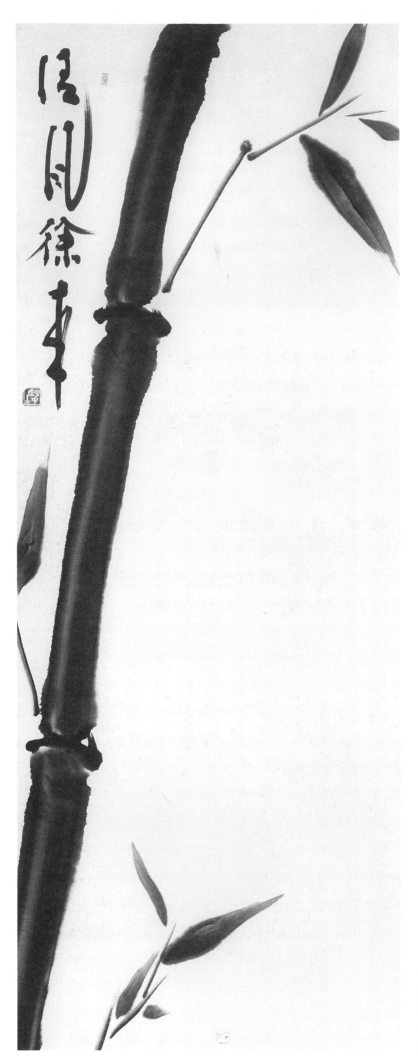

Bamboo by Terayama Tanchū

INSCRIPTION: *The fresh wind comes softly.*

Seifū jorai [Seifū omomuro ni kitaru.]

清風徐来 [清風　徐に来たる]

53 x 21 *inches* (135 x 53 *cm*)

Plum Blossoms (with inscription)

A plum tree weathers the hardships of winter and blossoms with the coming of spring. The severer the winter, the more fragrant its blossoms. Perhaps this parallel with the human condition explains the popularity of plum blossoms as a subject for painting.

The plum blossoms that appear with snow still on the ground have a special appeal, but so do plum blossoms that glow faintly under a misty moon. If there are plum blossoms that evoke peace of mind, there are also plum blossoms that display spirit and energy; when painting, the artist must mirror such characteristics in the brushwork.

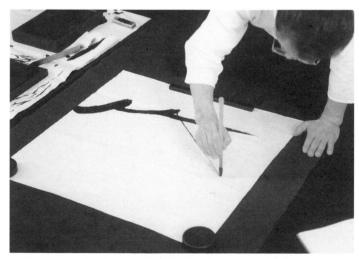

1 Brush a sturdy branch with heavy ink.

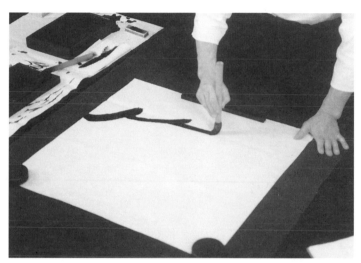

2 Move the brush boldly and powerfully to achieve a three-dimensional effect.

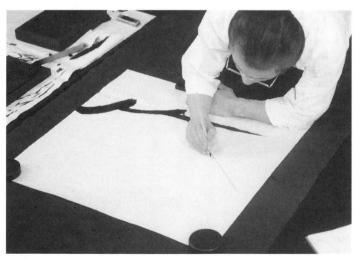

3 Brush a smaller branch with a thin brush and softer ink, moving slowly and focusing all your energy in each line. The line should be fine and tapering.

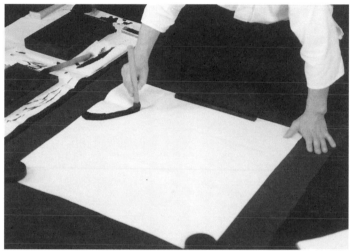

4 Brush in the blossoms carefully with a very fine brush.

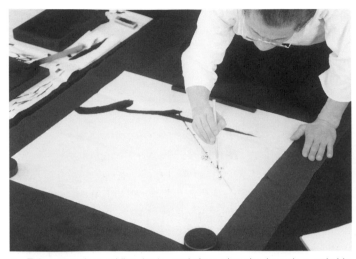 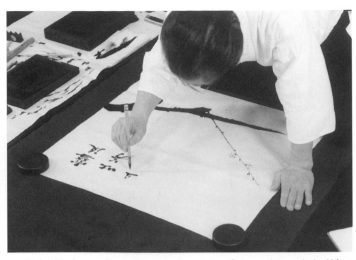

5 Take your time adding buds, and then give the branch a suitable amount of moss.

6 In the blank area, I've written the inscription *Setsugo hō wo haku* (After snow, the plum blossoms send forth their fragrance). Choose an inscription of your own in your own language, or imitate the inscription here. Keep in mind that an inscription works in combination with a painting and complements a sparse image more effectively than a full and intricate one.

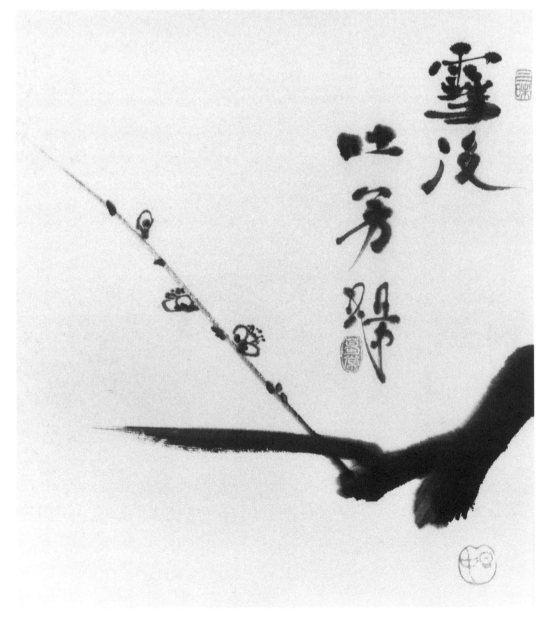

Plum Blossoms by Teraya-ma Tanchū
INSCRIPTION: *After snow, the plum blossoms send forth their fragrance.*
Setsugo tohō [Setsugo hō wo haku.]
雪後吐芳 [雪後　芳を吐く]
13 x 10 *inches (32 x 26 cm)*

Mount Fuji

What is it that makes Mount Fuji so beautiful? Grand and imposing at its base, it soars above the clouds, tall and commanding. Its perfect form stands not only as the ideal of a mountain, but inspires the ideal state of mind and heart—noble, expansive, and generous.

When we paint Mount Fuji, we borrow the image to symbolically represent this human ideal. If you can feel this ideal by simply looking at your finished picture, there is no need to add an inscription. To do justice to the image, one must strive for an expansive frame of mind and then practice and experiment until the clarity of the lines and the softness of the clouds flows from the brush without conscious effort.

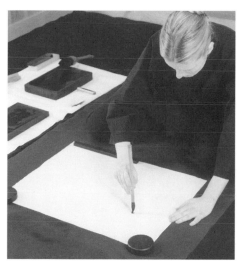

1 Clear your mind, determine the best point to start, and then brush in the first line.

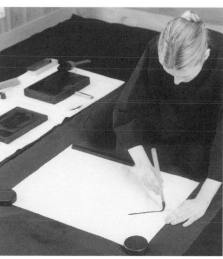

2 The slope to the left may be short, but its energy should continue to infinity.

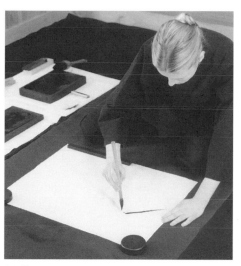

3 To represent the summit with carefully placed dots, let the brush descend slowly and deliberately. With your mind entirely focused, add two dots to mark the summit.

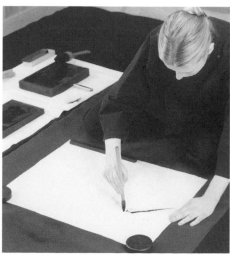

4 Now we move on to the right slope. This side seems to extend indefinitely. The expanse of Fuji's lower slopes gives the mountain its beauty, and this expansiveness is what we wish to express symbolically.

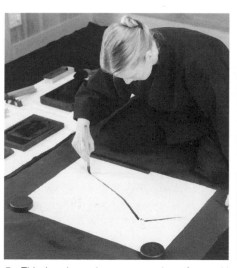

5 This is where the concentration of your *ki* shows.

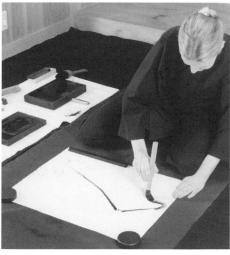

6 Brush in the clouds that cover the lower slopes of the mountain. Imagine yourself as the clouds and let yourself drift serenely along the slope of the mountain.

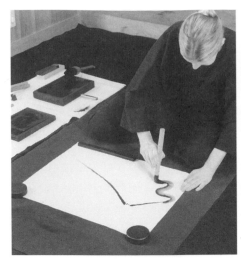

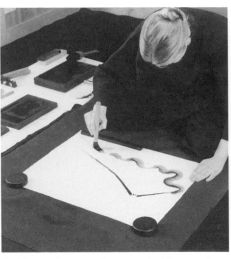

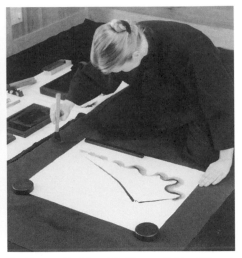

7 Let the stroke waft softly and gently.

8 The stroke extends outward without end.

9 Motsugai's *Mount Fuji* has a slightly different feel to it and, together with the exercise here, hints at the numerous possibilities of this theme.

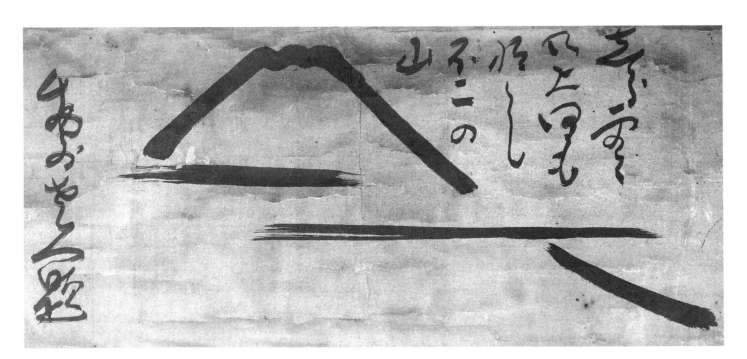

Mount Fuji by Motsugai
INSCRIPTION: *Above the white clouds, the mountain of non-duality (Fuji).*

11 x 23 *inches* (27 x 59 *cm*)

Motsugai Fusen (1794–1867) was an eccentric Sōtō Zen devotee who was better known as a martial artist than as a mendicant monk. In this seemingly crude painting of Mount Fuji, we can see his direct, no-nonsense spirit. The two lines forming the clouds around Fuji-san seem to extend for miles.

Daruma

Portraits of Daruma depict the essential image of Bodhidharma (the first Zen patriarch who went to China from India in the sixth century) as a way of representing the universal dharma *(teachings of the Buddha). Two classic portraits of Daruma, as well as my own version, round out this exercise. The second is by the Sōtō Zen monk Fūgai (1568–1654) and the third by the Rinzai Zen priest Hakuin (1685–1768).*

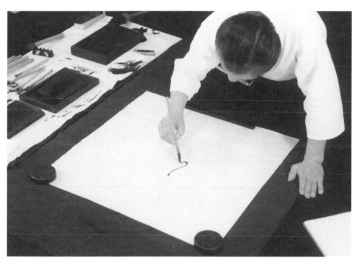

1 Begin by drawing in the nose in the center.

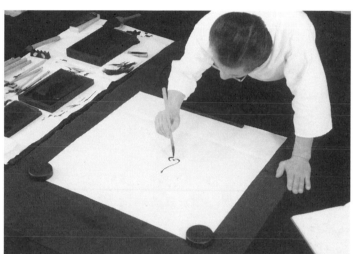

2 Next, add the nostrils.

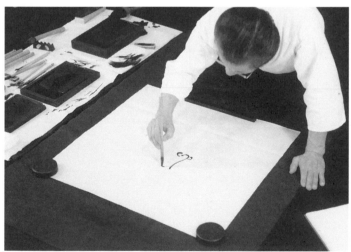

3 Continue with the eyes.

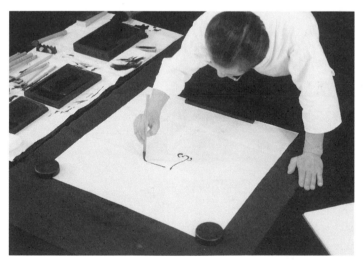

4 Draw the line over the left eye, and then the line over the right eye.

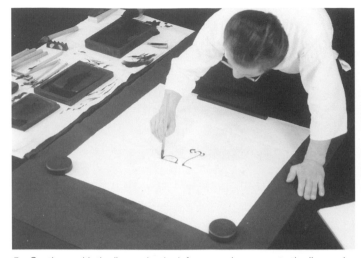

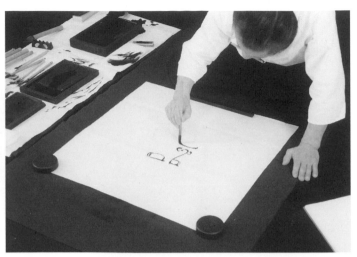

5 Continue with the line under the left eye, and move on to the line under the right eye.

6 Concentrating your energy, focus your strength in drawing the mouth of Daruma as a line with the ends turning down.

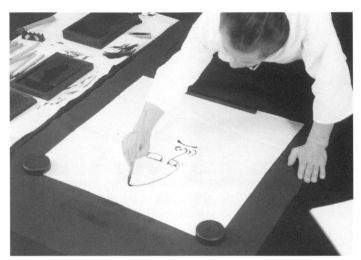

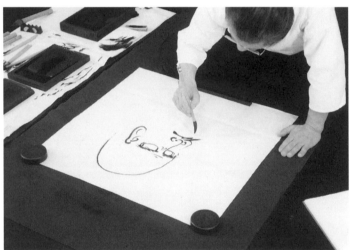

7 Draw the outline of Daruma's head.

8 Brush in the ear, the lines on the forehead, and the wrinkles at the corners of the eyes. Use weak ink for the beard and mustache. Finally, add the pupils of the eyes.

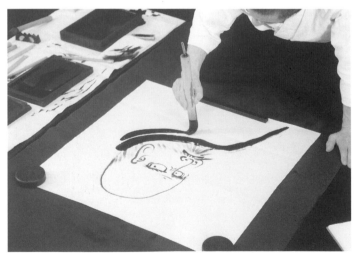

9 With a large brush fully charged with ink, brush in the lines of the robe to complete the painting.

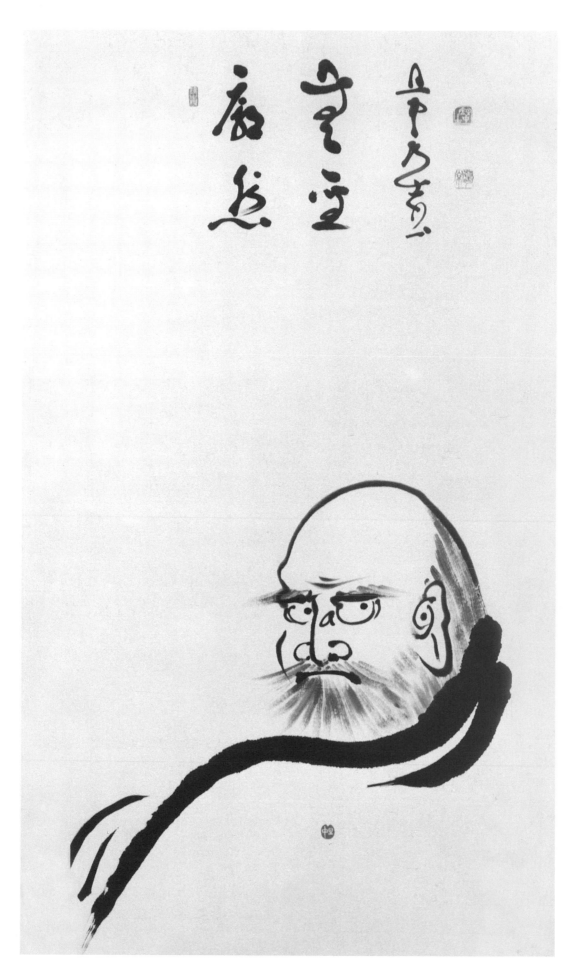

Daruma by Terayama Tanchū
INSCRIPTION: *Vast emptiness, nothing sacred!*
Kakunen mushō 廓然無聖

46 × 22 *inches* (118 × 55 *cm*)

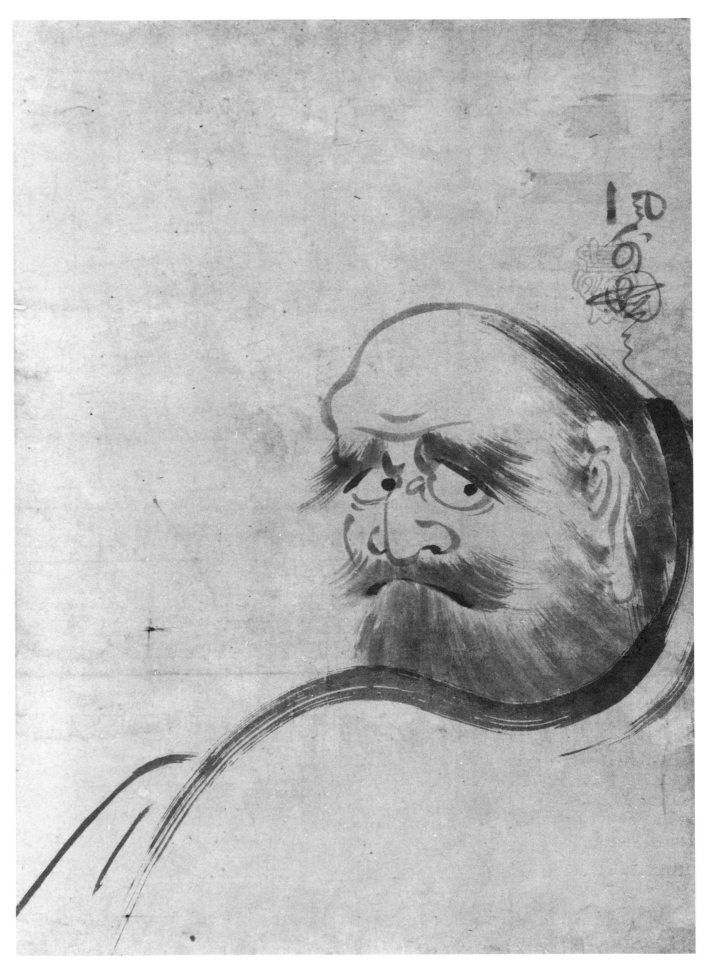

Daruma by Fūgai 17 x 13 *inches* (43 x 32 *cm*)

This portrait of Daruma was brushed by Fūgai, a Zen eccentric whose name means "fancy free." Fūgai spent much of his life living in caves as a hermit.

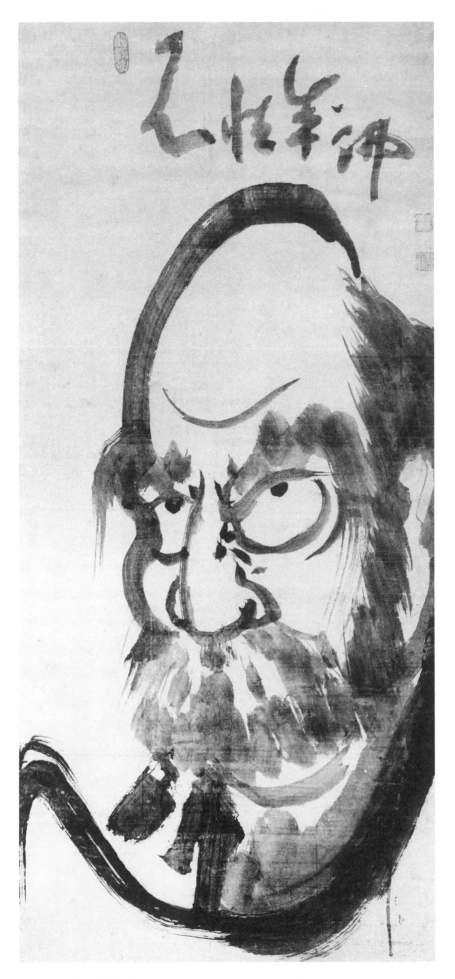

***Daruma* by Hakuin** 51 x 22 *inches* (130 x 55 *cm*)

This portrait of Daruma by Hakuin projects tremendous power—the power of Zen meditation and profound insight. The inscription commands the viewer to "See into your nature and become Buddha!"

Wall-Gazing Daruma

This is an abbreviated image of Daruma facing the wall of his cave at Shorinji in deep meditation, brushed in the style of Jiun Onkō (1718–1804). Since this is a symbol of universal life-force, the image transcends all boundaries.

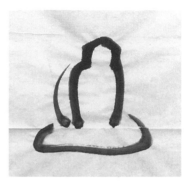

Finished Daruma.

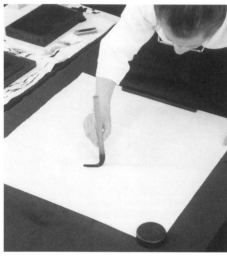

1 Draw the upper left side of the body, starting from the top as shown.

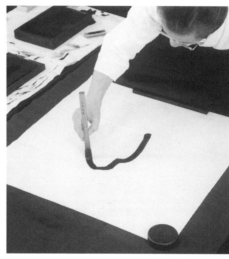

2 Brush the head, shoulders, and torso.

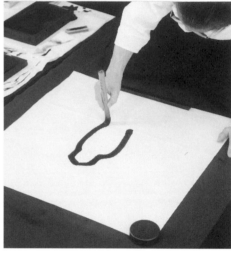

3 Brush the right side while maintaining the proportion of the figure.

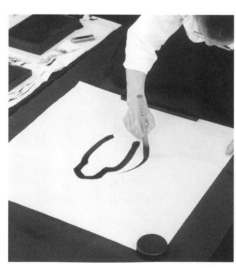

4 Since the Daruma figure is seated facing slightly to his left rather than looking straight ahead, add a line to represent the figure's back.

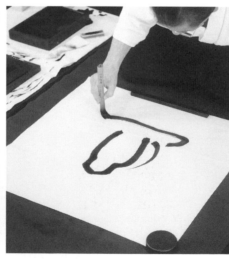

5 Without haste or hesitation, brush in a line representing the lower part of the Daruma as he sits in Zen meditation.

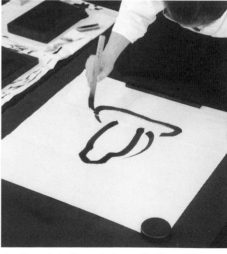

6 Extend the line to balance the figure and then withdraw the brush, keeping your energy focused.

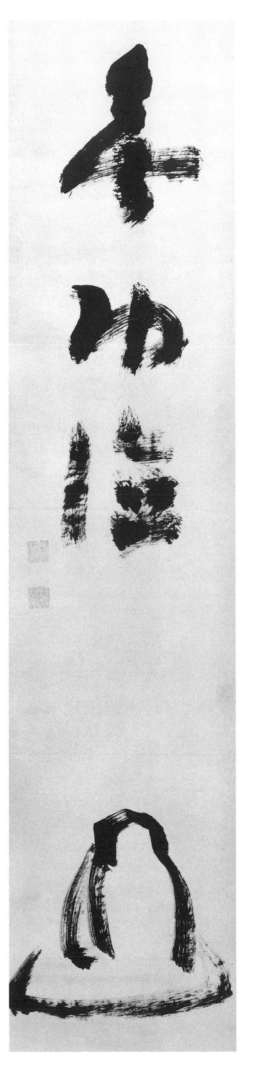

Daruma by Jiun Onkō
48 x 11 inches (122 x 28 cm)

This is a portrait of Daruma facing the wall in meditation. Onkō was a renowned Buddhist scholar and teacher whose study began in the esoteric Shingon sect. He liked to use a dry brush and compose in broad strokes. The inscription reads, *mu-kudoku* (無功徳), or "No merit!" This was Daruma's reply when Emperor Wu asked, "I've constructed dozens of Buddhist temples, supported hundreds of monks and nuns, and sponsored countless religious ceremonies. How great is my merit?"

"One-Stroke" Daruma

The next work is a simple "one-stroke" Daruma. Press the brush firmly into the paper.

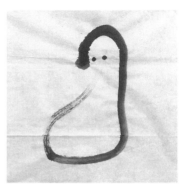

Finished Daruma. Note the subtle differences in proportion between the finished sample and the one brushed in the exercise.

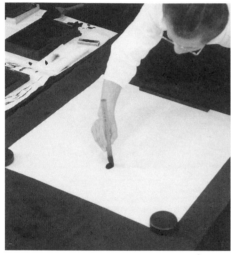

1 Brush the Daruma in one long, sweeping stroke. Begin with the left upper body, starting from the top as shown.

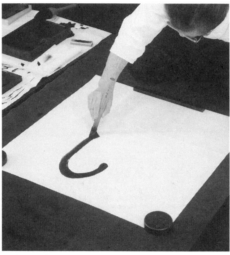

2 Continue on to the right side of the upper body, maintaining a pleasing balance with the left side.

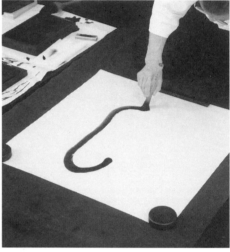

3 Continue with the back and lower back. Add a slight curve and a suggestion of roundness to finish the back.

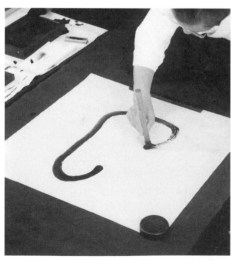

4 Move on to the lower part.

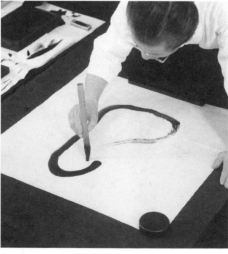

5 Finish and withdraw the brush from the paper.

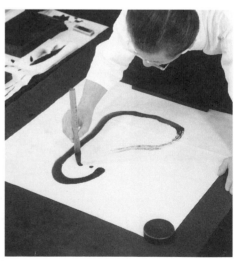

6 Apply the finishing touch by adding the eyes.

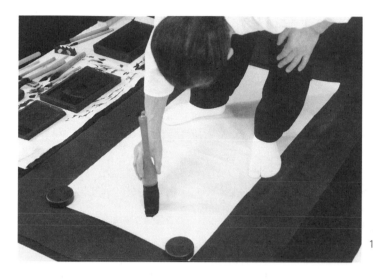

The finished piece.

Ji-Wa-Choku (Compassion, Harmony, Honesty)

This work is written on a ren'ochi *sheet of paper that measures approximately 20 x 53 inches (52 by 135 centimeters). The middle character,* wa, *is the subject of a fascinating series of works on page 77.*

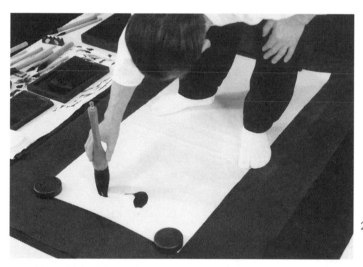

1 Begin writing slowly and deliberately.

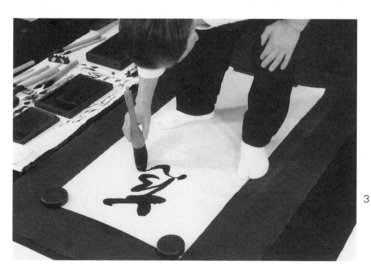

2 Brush the two dots that begin the character *ji* (慈) for "compassion" or "benevolence."

3 Complete the character by adding the bottom element, which is the grass-script form of the character *kokoro* (心), meaning "heart." For reference see the chart on page 12.

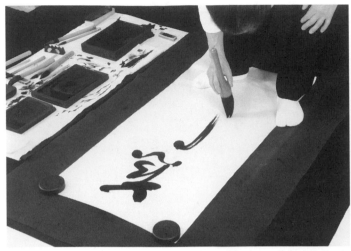

4 Proceed to the vertical stroke of the character *wa* (和), meaning "harmony."

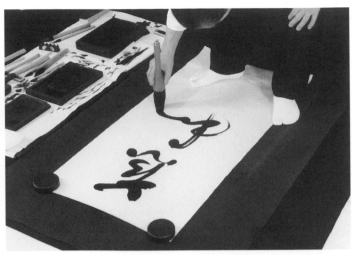

5 The last element of the character *wa* extends horizontally.

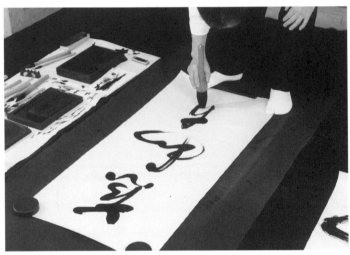

6 Move on to the character *choku* (直), meaning "honest" or "straightforward."

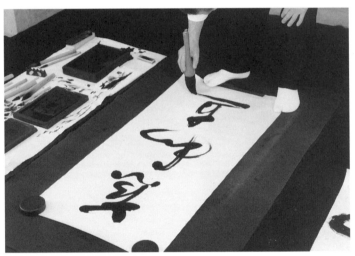

7 The final stroke stretches horizontally and seemingly without limit.

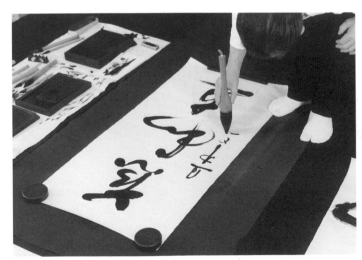

8 Add your signature in a stylized manner.

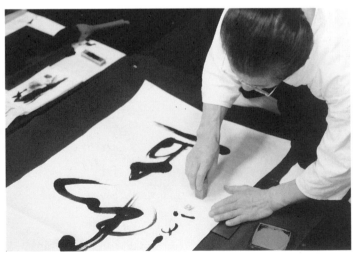

9 Traditionally, a work is completed by adding a seal impression.

PART IV
APPRECIATION

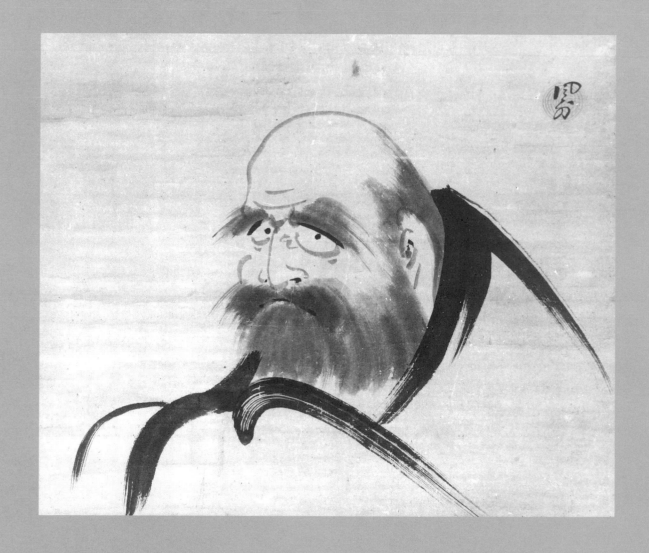

Works by Old Masters

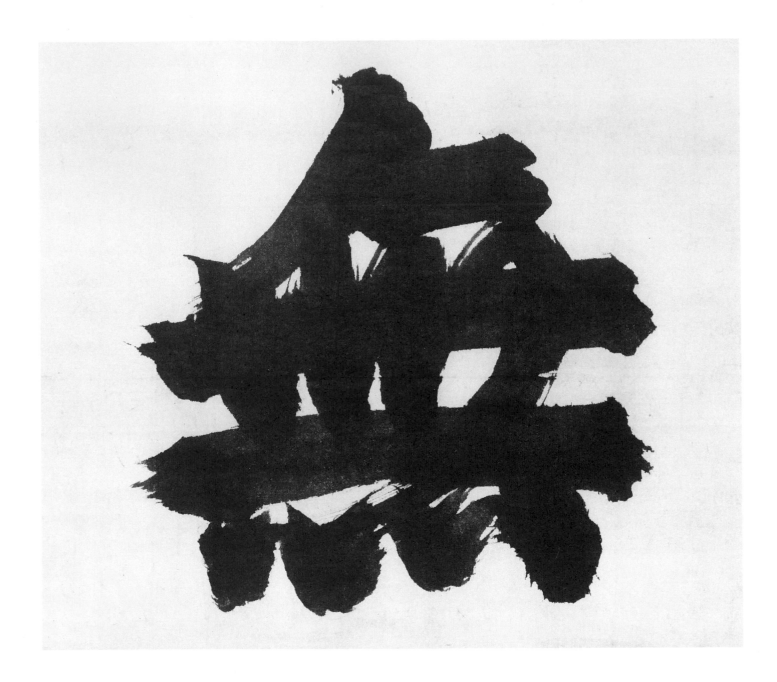

Nothing by Shidō Munan

13 x 18 *inches* (33 x 46 *cm*)

Mu　無

There are many examples of the character *mu* brushed by Zen monks, but I have never seen one more powerful than this. The massive, forceful brushstrokes are almost overwhelming, and the character seems to have exploded from the paper. The character itself is not large, but it gives the impression of being huge, and it has a galvanizing effect on the viewer.

Munan (1603–76) did not become a Zen monk until age fifty, but he had studied under the Zen master Gudō for many years. Gudō gave Munan the *kōan* (a conundrum to aid Zen meditation) "Originally, a human being has nothing at all" to ponder. Hardly sleeping or eating, Munan eventually solved the riddle to Gudō's satisfaction and was ordained a Zen monk. Like many Rinzai masters, Munan was dynamic and direct, a powerful speaker and no-nonsense teacher, who emphasized "waking up" in the here and now. All those qualities are manifested in this calligraphy.

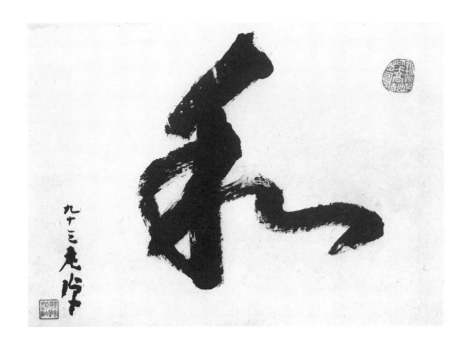

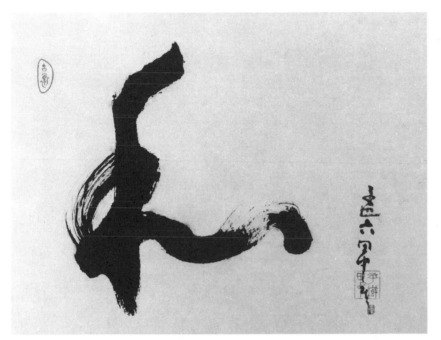

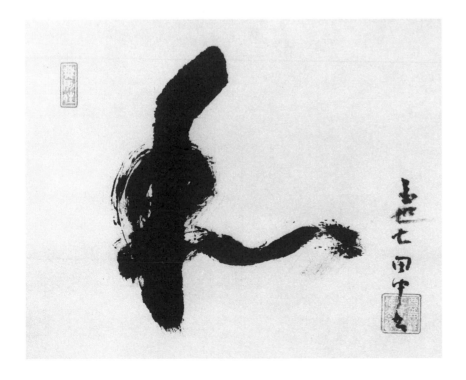

Harmony by Hirakushi Denchū
13 x 16 inches (32 x 41 cm)
Wa 和

Here is the character *wa*, "harmony," brushed by the famous sculptor Hirakushi Denchū (1872–1979). The first plate was done when he was ninety-three, the second plate at the age of 106, and the third plate at the age of 107, the year of his death. Although the first version of *wa* is powerful, the lines of the last version radiate vitality, revealing greater clarity and depth. This display of energy is testimony to a lifetime of study. In this world, relying on physical strength is pointless—one must break through to the realm of *ki*.

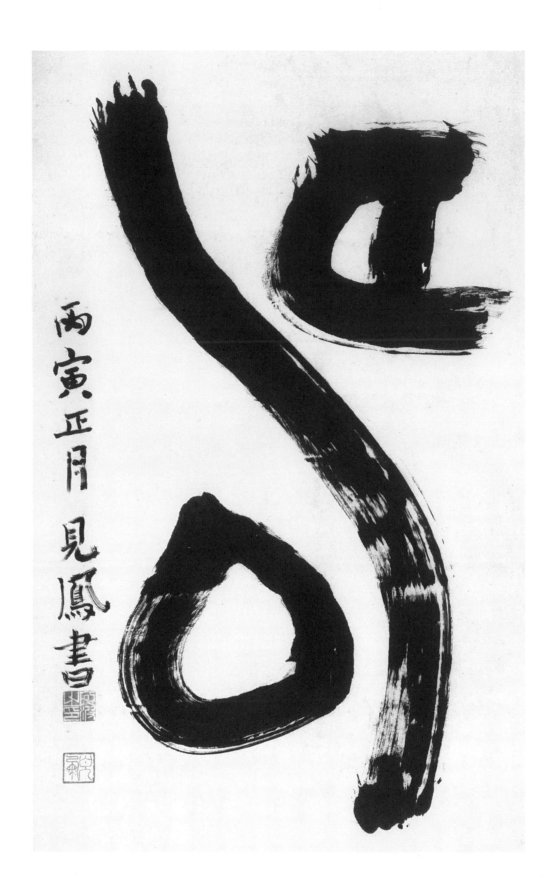

Longevity by Awa Kenzō
35 x 57 *inches* (90 x 147 *cm*)
Kotobuki/Ju 寿

This piece is by Awa Kenzō (1880–1939), the famous Zen archer/philosopher featured in Eugen Herrigel's classic *Zen and the Art of Archery*. In that book, Herrigel describes Kenzō's amazing ability to hit the bull's-eye of a target at night, illuminated only by the light of a single incense stick, and then to split that arrow with a second shot. This calligraphy is the Chinese character *kotobuki*, "longevity," in which the complex character is reduced to a few brushstrokes. The effect is extraordinarily powerful and vibrant. It was brushed on a full-sized sheet of paper and is dated January 1926, when Kenzō was forty-six years old.

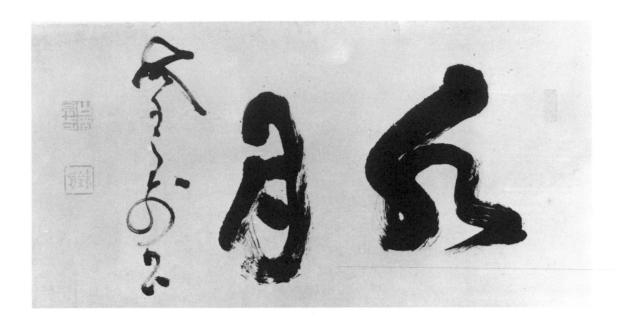

Water–Moon by Yamaoka Tesshū

13 x 27 *inches* (33 x 68 *cm*)

Suigetsu　水月

These two characters brushed by Tesshū read *suigetsu*, "water–moon," a central concept in both swordsmanship and Zen: water receives the moonlight without discrimination; the moon illumines all things without discrimination. Tesshū used a soft brush to create this work. Both characters radiate light and energy, and are very pleasingly formed. Tesshū's signature at the far left nicely balances the somewhat lower position of the moon character in the middle. The calligraphy projects strength and stability, the qualities of a master of the sword, Zen, and the brush.

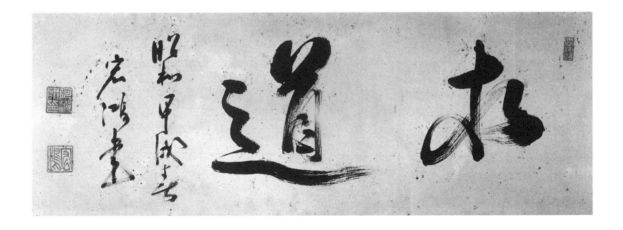

Search for the Way by Awa Kenzō

11 x 34 *inches* (29 x 87 *cm*)

Gudō/kyūdō　求道

These two characters can be pronounced in two ways: *kyūdō*, a homonym for *kyūdō*, "the Way of the Bow (Japanese Archery)," and *gudō*, "Search for the Way [in a straightforward and ceaseless manner]." The brushstrokes are calm and settled, yet very bold and imposing. We can sense the master's deep understanding of the Way. It is dated 1934, when Kenzō was fifty-four years old. Here he uses the pen name Kōkō, "Great Swan," a symbol of "life lived to its fullest."

Kenzō began his study of *kyūdō* at age twenty-one and by age twenty-eight he was the top competitor in national contests. Following an enlightenment experience at age forty-one, Kenzō achieved a widespread reputation as a "philosopher/saint of the bow."

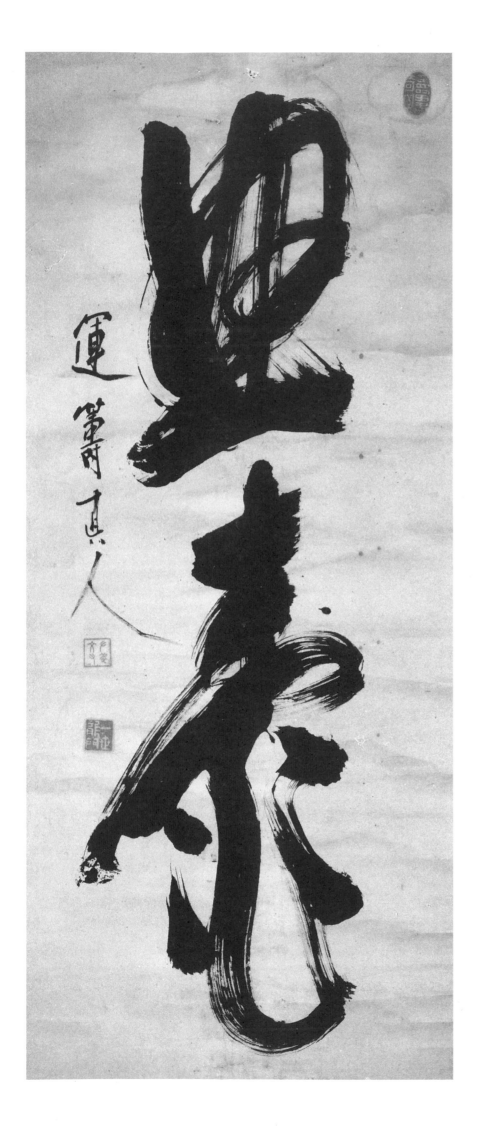

Fierce Frog by **Hirayama Shiryū**
51 x 22 *inches* (131 x 56 *cm*)
Doa 怒黽

These two large characters by Shiryū (1759–1828) read "Fierce Frog," referring to the following tale: Long ago, a Chinese emperor was leading his troops to an important battle when he noticed a tiny frog puffed up, ready to attack the huge intruders on his territory. Impressed by the frog's fighting spirit, the emperor exhorted his men to display similar determination in facing their foe.

Shiryū was the epitome of the severe samurai. He avoided women, slept in the training hall, wore one thin robe all year long, and rose at four in the morning to practice martial arts, in which he is said to have mastered all the martial disciplines. Following morning training, Shiryū studied military manuals. As he read, Shiryū would crush unhulled chestnuts and punch and stab at a wooden board to toughen his hands and fingers.

When Shiryū wrote calligraphy such as this he let out a terrific shout, and often the ink from his brush would fly as high as the ceiling. The power exhibited here is extraordinary, vast, and overwhelming. The top character displays the fierce, raging nature of Shiryū's brushwork, and the bottom character brims with intense energy—there is no slackness or uncertainty at all.

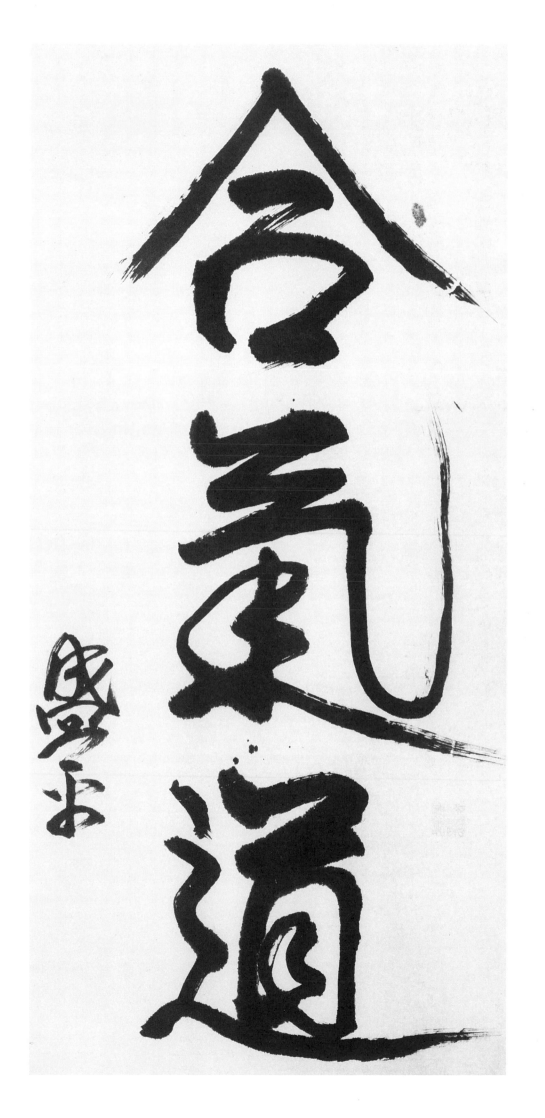

Aikidō by Ueshiba Morihei

70 x 35 *inches* (178 x 91 *cm*)

Aikidō　合気道

Ueshiba Morihei (1883–1969) is per-
haps the greatest martial artist Japan
has ever produced. He mastered many
martial arts as a young man, and also
studied under the Ōmoto-kyō religious
leader Deguchi Onisaburō (1871–1948).
Like many other masters featured in
this section, Ueshiba had a profound en-
lightenment experience. This occurred
at age forty-two when he realized "I
am the Universe!" Ueshiba went on
to develop and found the now-popular
discipline of Aikidō, "the Way of Spiri-
tual Harmony."

　This huge scroll, with the charac-
ters for *Aikidō*, hangs in the practice hall
of the Aikikai Headquarters in Tokyo,
and it is truly imposing both in scale
and power. The unhurried brushstrokes
are rich and vibrant, and there is a won-
derful balance between the flow of
centrifugal and centripetal energy. The
calligraphy radiates vitality, and we can
sense that the artist has achieved true
harmony of body and spirit.

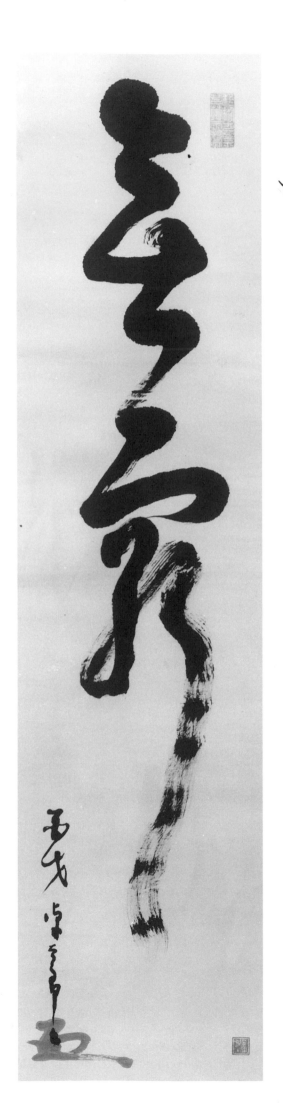

Mukyū (*No Limit*) by Hirakushi Denchū
54 x 13 inches (138 x 34 *cm*)
Mukyū　無窮

These two characters, flowing together in a seamless unity, read *mukyū*, meaning "eternity," "infinity," or "immortality." They were brushed by Hirakushi Denchū at age one hundred. Here, we have another piece of calligraphy that is remarkably natural, pure, and deep, a creation of the spirit rather than the body. This piece was brushed in the state of "no-mind" and in a distinctly individual manner. It is not so much the kind of Zen art that originates in profound meditation as the Zen art of completeness, truth, vitality, and purity.

Calligraphy by Taichi Sokei

41 x 12 inches (105 x 31 *cm*)

Sokei (1290–1366) was a Sōtō Zen monk who studied under the great master Keizan (1268–1325), and he also trained for a time in China. He spent nearly twenty years in retreat, living the simple life of a hermit monk.

This unusual calligraphy takes a line from a Chinese poem: "In the rain, a willow tree's deep reflection on Dragon Pond." Sokei used a bamboo brush to compose this piece, but there is nothing stiff about the brushwork, and the calligraphy seems to dance across the paper. The finish is wonderfully creative: Sokei ran out of room at the end of the paper but effortlessly shifted the composition to the left side as he added the last two characters. The brushstrokes still appear unsullied, bright, and fresh, even though the scroll is more than six hundred years old. Original and refreshing, this piece of calligraphy is a delight to behold.

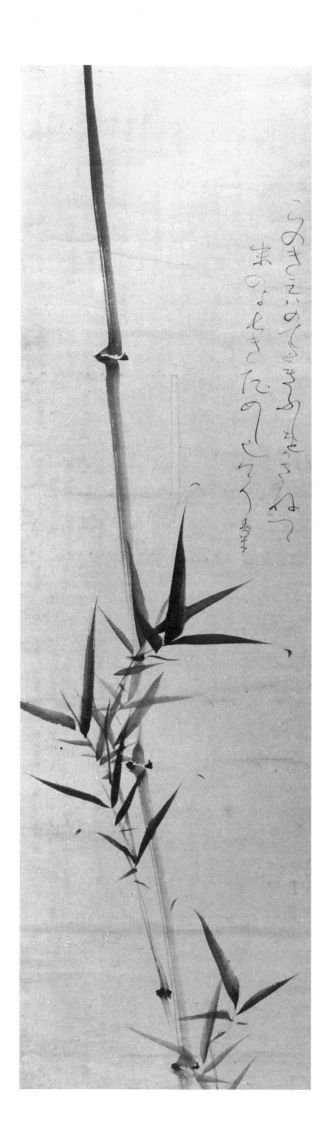

Bamboo by Ōtagaki Rengetsu

40 x 12 *inches* (101 x 30 *cm*)

This elegant work of art by the Buddhist nun Rengetsu (1791–1875) is a wonderful example of perfect integration between painting and calligraphy. The bamboo was composed from top to bottom with a few supple brushstrokes and then the leaves were added, extending upward in a vibrant and vivid manner. This is not a still-life painting of a bamboo; it emerged as if alive from Rengetsu's heart. The calligraphy is a *waka poem*: This gentleman / grows and grows, / auspiciously / learn from it and / you will ever flourish.

The poem was expertly placed in just the right space and seems to dance across the paper. The overall effect of this work, brushed when Rengetsu was eighty years old, is very refreshing.

Raised in the castle of a samurai lord, Rengetsu became a nun at the age of thirty-three after losing two husbands and several children. She supported herself by making pottery inscribed with her poetry and paintings, and she also produced many other works of art. She was a preeminent cultural figure in Kyoto during her time, and her pottery, calligraphy, and paintings are still highly prized by connoisseurs.

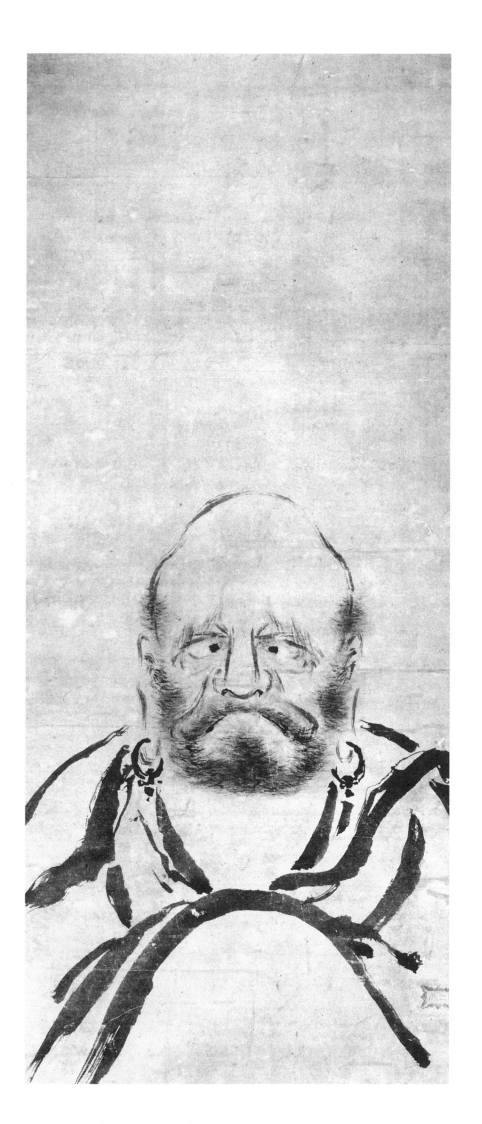

Daruma by Miyamoto Musashi
36 x 15 *inches* (91 x 39 *cm*)

This portrait of Daruma by the master swords-
man Miyamoto Musashi (1584–1645) could be
called "Daruma Face-to-Face!" The brushstrokes
of Daruma's beard are amazingly vivid, created
not with brush pressure but with *ki* energy. There
is nothing sluggish or idle here, and the entire
piece bristles with fierce energy, just as we would
expect from an intense, accomplished swords-
man. This awe-inspiring Daruma gives the viewer
no quarter; it is like having a direct encounter
with the Grand Patriarch himself.

Calligraphy by Ryōkan

8 x 10 inches (20 x 26 cm)

Sōtō Zen tends to be more low-key than Rinzai Zen. Steady-but-sure Zen meditation is stressed over dramatic enlightenment experiences. This calligraphy is by Ryōkan (1758–1831), a Sōtō Zen master who lived in a remote part of Japan as a beggar monk. Ryōkan spent his days in meditation, composing poetry, practicing calligraphy, playing with the village children, and drinking saké with local farmers. His brushwork has always been treasured, and this splendid example is a quote from the *Bommō-kyō* (Brahmajāla-sūtra): "Neglecting to be thankful for good words and failing to control anger are grave sins." We can sense Ryōkan's pure and gentle spirit in the brushstrokes—quiet, subtle, and reserved.

An excerpt from *Following the Solitary Path* by Miyamoto Musashi

7 x 42 inches (17 x 107 cm)

Dokkōdō 独行道

This is the opening section of Miyamoto Musashi's precepts, which he entitled *Following the Solitary Path*, or *The Way of Walking Alone*. The brushwork is supple, refined, and decisive and appears to flow over the paper like water. The first six precepts are:

- Do not turn your back on the various Ways of this world.
- Do not scheme for physical pleasure.
- Do not intend to rely on anything.
- Consider yourself lightly; consider the world deeply.
- Do not think in acquisitive terms.
- Do not regret things about your own personal life.
 —from *The Book of Five Rings*, translation by William Scott Wilson

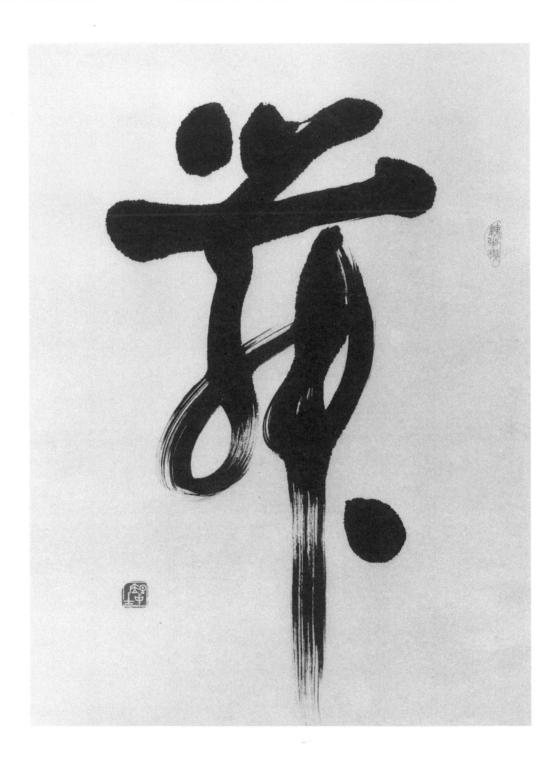

Dance

26 x 19 *inches* (66 x 48 *cm*)

Mai 舞

The character *mai*, meaning "dance," takes the form of a figure dancing in a robe with long, flowing sleeves. To dance beautifully one must enter fully into the dance. If the dance routine has a theme, the dancer can only express it by immersing his or her spirit fully in the theme. To do that, the participant must be flexible in mind and body but relentless in his or her training.

The art of *sho*, like the art of dance, requires total immersion. Throw yourself into the dance of ink on paper and seek to express yourself deeply.

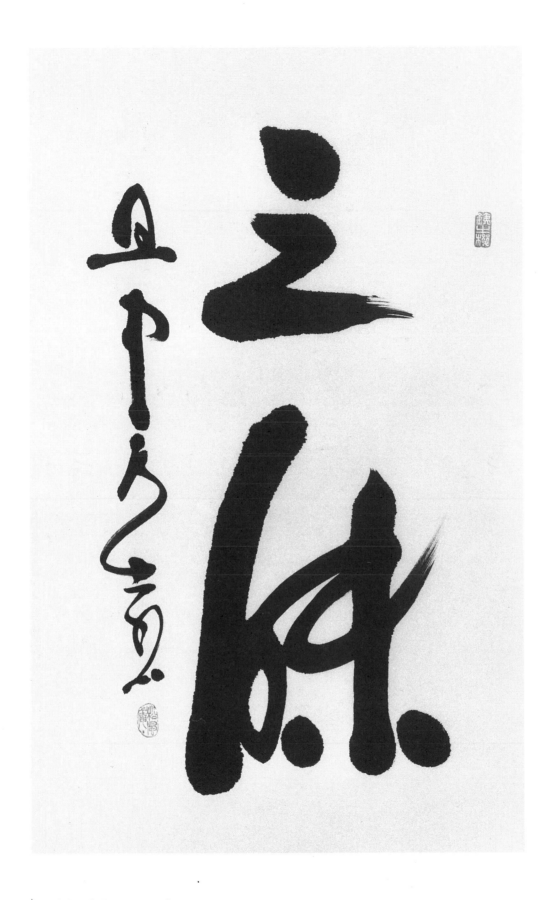

Spiritual Concentration

22 x 13 *inches* (57 x 34 *cm*)

Sammai 三昧 (Sanskrit: samādhi)

Sammai is a state in which the mind is tranquil and unified. It is extremely difficult to express in calligraphy. Strive for total awareness: practice and train single-mindedly, and when you have forgotten all about practice and are absorbed only in wielding the brush, you will have attained the right frame of mind.

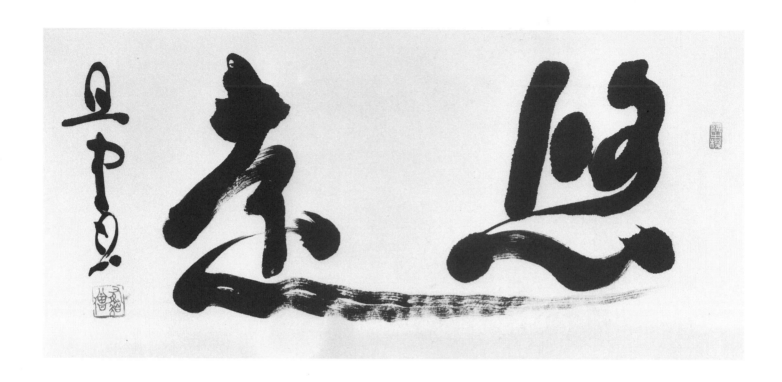

Remoteness

13 x 27 *inches* (33 x 69 *cm*)

Yūen　悠遠

Yūen signifies remoteness and distance. Immersed in the spirit of infinite space, I took up the brush.

Even though one may enter into this spirit with time and practice, expressing it in finite space requires technique. The best approach is to study extensively the work of the masters who have achieved this spirit. Then, nothing remains but to forget their work and simply wield the brush freely.

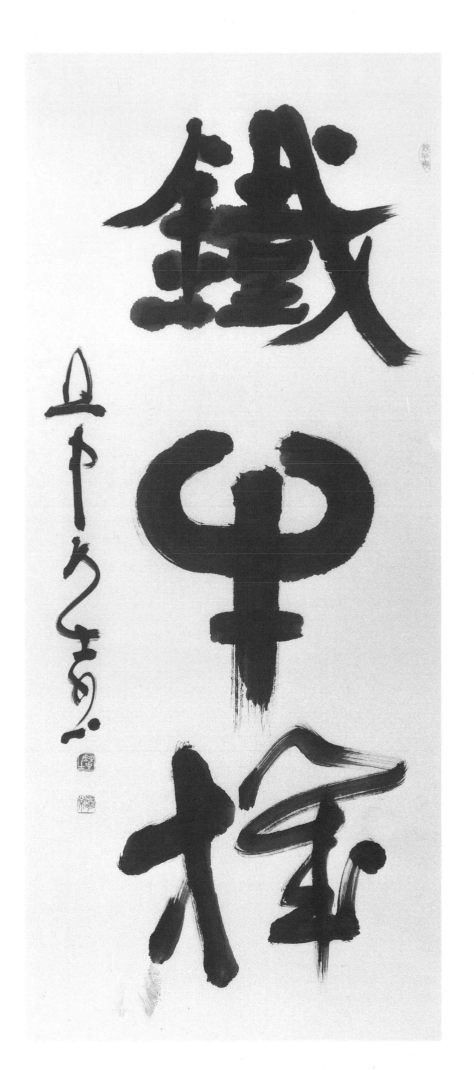

The Iron Ox Functions!

53 × 22 inches (134 × 55 *cm*)

Tetsugyū Ki [Tetsugyū (no) hataraki]
鉄牛機 [鉄牛の機]

This is a visual *kōan*, a Zen riddle. The line of the title refers to the thirty-eighth case of the *Hekiganroku*, or *Blue Cliff Record*, a collection of Zen *kōan*. In the *kōan*, a statue of an iron ox crosses the Yellow River—a miracle similar to walking on water. (A commentary on this *kōan* can be found in *Two Zen Classics*, translated by Sekida Katsuki.)

Since the character for *tetsu* consists of many strokes, it is written in standard script with thin strokes. The *kanji* for *gyū* represents the head of a bull with protruding horns, and to emphasize this, this *kanji* is written in seal script with heavy strokes. *Hataraki* is written briskly in grass script.

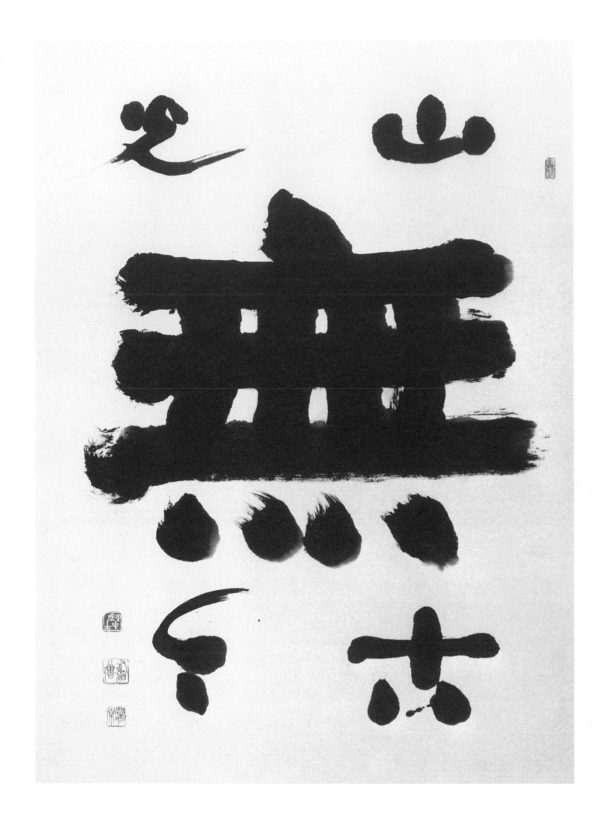

For the Mountain Vista, There Is No Past or Present.
40 x 25 inches (101 x 64 *cm*)
Sankō MU kokon [Sankō ni kokon nashi] 山光無古今 [山光に古今無し]

Sankō ni kokon nashi: A view of clear mountains is changeless from past to present, and anyone who stands before these mountains and takes in this timelessness in that instant possesses the infinite.

The character *mu* literally means "no-thing" or "no," but in Zen *mu* also expresses the state of total awareness that precedes knowledge and experience. This *kanji* is brushed resolutely in thick, bold strokes in standard script. Above it is written the two-character word *sankō*, meaning "mountain view," and below it is *kokon*, meaning "past and present." These four smaller *kanji* complete the phrase and strike a balance with the bold *mu*.

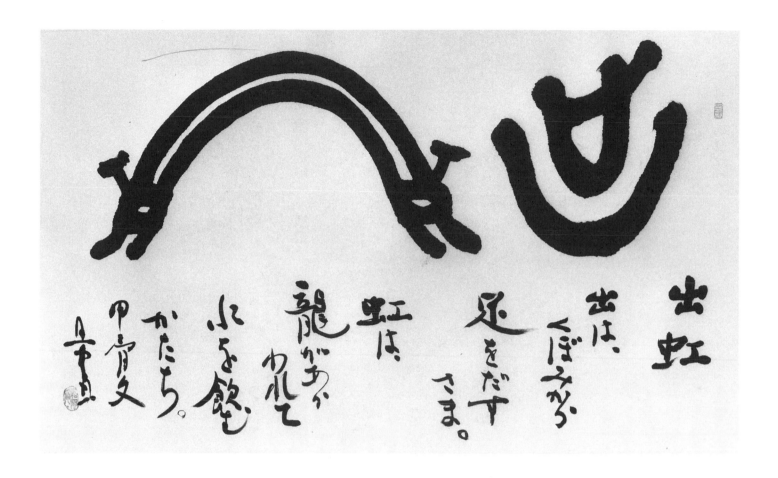

A Rainbow Appears

15 x 27 *inches* (39 x 68 *cm*)

Shukkō 出虹

出は、くぼみから足を出すさま。虹は、龍があらわれて水を飲むかたち。甲骨文

The large *kanji* at the right for *shutsu* (出) in *shukkō* depicts a foot coming out of a hole, and the *kanji* for *kō* (虹) shows a dragon appearing and drinking water. These two *kanji* are written in *kinkeibun*—the form of ancient writing that was cast on bronze vessels or engraved in bone or tortoiseshell in Shang-period China (1600–1000 B.C.). The inscription, explanatory rather than inspirational, informs the viewer of the *kanji*'s background.

Kinkeibun is the form of *kanji* that is closest to pictographs, and it was my intention to paint these characters as pictures that express mystery and depth and then balance them against the smaller script of the inscription.

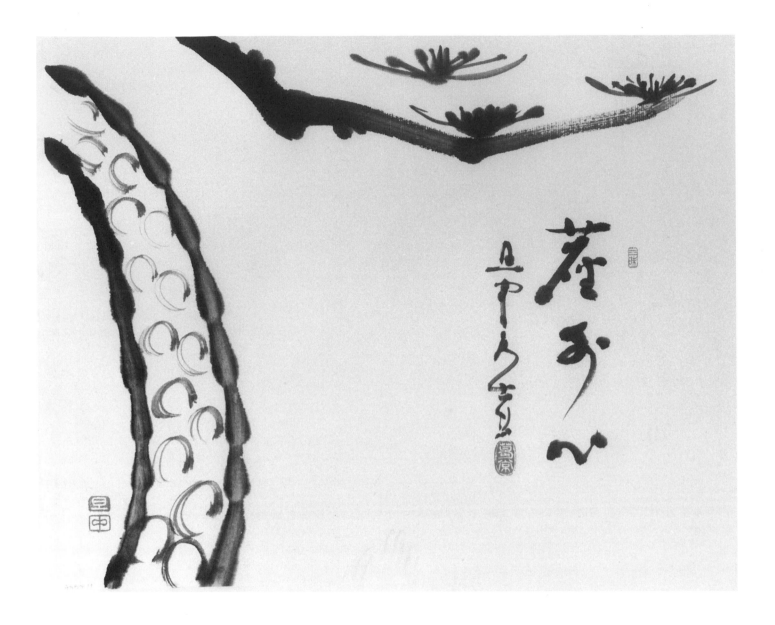

Pine

11 x 14 *inches* (27 x 35 *cm*)

INSCRIPTION: *Beyond the worldly mind.*

Jingai shin [Jingai no kokoro]　塵外心 [塵外の心]

A breeze whispering through the pines blocks out the dust of this world. In ancient Chinese and Japanese texts, "dust" refers to the din and tumult of the everyday world. To convey a spirit that is free of this dust, where a pure breeze rustles in the pines, the calligrapher must free himself from worldly restraints and, further, possess a solid foundation for both painting the pine and brushing the inscription.

First, brush a meticulously exact image of a pine, line by line. Then reduce and simplify to find your own expression of the essence of the pine. Once you have grasped the essence, search for the fewest necessary strokes. The point and appeal of an inscription is the way it fills in for what the picture cannot express. Choose an expression with *kanji*, or use something in your own language, and imbue it with an expressiveness appropriate to the subject.

GLOSSARY

aozumi 青墨 "blue ink." An ink that contains a blue pigment (indigo) and produces an extremely deep black, a quality desirable in Zen painting.

Bodhidharma 菩提達磨 A prince of southern India who brought meditation techniques of Buddhism to China in the early sixth century A.D., thus becoming the First Patriarch of Zen. Bodhidharma is famous for sitting before a wall in meditation for nine years. His determination is the source of many legends, one being that his constant meditation caused his arms and legs to shrivel away. According to another, he cut off his eyelids to keep from falling asleep during meditation. His Japanese name, Daruma, is now used for the dolls with glaring faces that always right themselves when knocked over.

boku See *sumi.*

boku-jū 墨汁 Ready-made ink. Another word for this is *boku-eki.*

Daruma 達磨 The Japanese name for Bodhidharma, the First Zen Patriarch. See also Bodhidharma.

Dharma The law, doctrine, or teachings of the Buddha.

ensō 圓相 or 円相 The Zen circle. A simple circle executed with a single brushstroke. In Zen, this circle is a symbol of enlightenment.

fude 筆 Brush. The *kanji* 筆 can also be read *hitsu,* as in Hitsuzendō 筆禅道.

gasenshi 画仙紙, 画牋紙, or 雅宣紙 Chinese paper that is used for painting and calligraphy.

grass script See *sōsho.*

gyakunyū (zōhō) 逆入 (蔵鋒) The technique of concealing the trace of the brush tip in a brushstroke by moving the brush in the direction opposite of the brushstroke and then reversing course.

gyōsho 行書 A style of writing generally translated as "semicursive script" or "running script."

hanshi 半紙 Paper for calligraphy practice measuring approximately 10 by 13 inches (26 by 34 cm). Other sizes include *zenshi* (the largest size; approximately 28 by 53 inches / 70 by 135 cm), *hansetsu* (approximately 14 by 53 inches / 35 by 135 cm), and *ren'ochi* (see entry).

hara 腹 or 肚 Literally, the abdomen or belly. However, *hara* often refers to one's mind, intention, or resolution. *Hara* can also be equivalent to *tanden,* the body's center. In this sense, *hara* is the physical and spiritual center of one's body. See also *tanden.*

hōbō 鋒芒 The abrasive grain of the inkstone.

hyakue 百会 An acupuncture point located at the very top of the head.

kaisho 楷書 A style of writing generally translated as "standard script," "formal script," or "regular script." *Kaisho* developed from *reisho* from the first to the third century A.D. This style of writing is now used for documents and is the basis for modern printed *kanji.*

kana 仮名 The two Japanese syllabaries, the most common being the cursive *hiragana* and the other being the squarish *katakana.* Both syllabaries consist of 46 (formerly 48) phonetic symbols.

kanji 漢字 "Chinese characters"; the term for the complex written characters in Japanese. *Kan* is the Japanese reading of the *kanji* for the Han dynasty, and *ji* means "letter(s)." Thus, "Han writing."

ki 気 Energy, or the universal and fundamental energy of being. It can be directed but not contained by the mind. See also *reiki.*

konton-kaiki 混沌開基 *Konton* is the primodial void, a state of "chaos" that preceded the separation of Heaven and Earth. *Konton-kaiki* is the starting point from which all things originate and from which all things eventually return.

mu 無 *Mu* means "no-thing," "not," or "non-existence." In Zen, *mu* can also signify pure human awareness that precedes experience or knowledge.

mujibō 無字棒 The Zen line, or the "line of nothingness." This is a single straight line, brushed with total concentration. In Hitsuzendō, the *mujibō* is the starting point for practice.

mu-shin 無心 Literally "no-mind." *Mu-shin* is a state beyond thought, emotions, and expectations. One who has achieved *mu-shin* is able to act free of any mental or emotional attachments.

reiki 霊気 A spiritually guided healing energy.

reisho 隷書 A style of writing translated as "scribe's script," "clerical script," or "official style." *Reisho* was developed from *tensho* (seal script) in the third century B.C. for writing more rapidly with a brush. *Reisho* is characterized by square forms that tend to stretch horizontally rather than vertically.

ren'ochi 聯落 A size of paper measuring approximately 21 by 53 inches (52 by 135 cm). It is the result of cutting one *ren* (measuring approximately 7 by 53 inches / 18 by 135 cm) from *zenshi,* or a full sheet (measuring approximately 28 by 53 inches / 70 by 135 cm). See also *hanshi.*

rōkyū 労宮 An acupuncture point in the center of each palm.

running script See *gyōsho.*

sammai 三昧 The Japanese word *sammai* is derived from the Sanskrit term *samādhi*, which is the highest state of mental concentration. This is a state of full mental alertness free from emotional disturbances.

scribe's script (clerical script or official style) See *reisho*.

seal script See *tensho*.

semicursive script See *gyōsho*.

sho 書 Literally, "writing," but used for calligraphy in general.

shodō 書道 Literally, the "Way of Calligraphy." *Shodō* is the discipline of calligraphy. As taught by Terayama Tanchū, *shodō* is a method of unifying mind and body in action.

shōen-boku or *shōen-zumi* 松煙墨 Literally, "pine-smoke ink." This ink was originally made from the soot of burning pine or resin. Compared to *yuen-boku*, *shōen-boku* has a bluish hue and gives a softer impression.

shōnen sōzoku 正念相続 *Shōnen* is true-thought or right-mindedness. Right-mindedness can also be interpreted as undistracted concentration. *Sōzoku* is continuation. *Shōnen sōzoku* can therefore be considered a state of continuous true-thought.

shūhitsu 収筆 Literally, "withdrawing the brush." *Shūhitsu* is the act of removing the brush from the writing surface.

sōsho 草書 A style of writing often referred to as "grass writing" or "grass script." *Sōsho* developed from *reisho*. In *sōsho*, the characters are radically abbreviated, the resulting forms often being indecipherable to anyone not trained in calligraphy.

standard script (formal script or regular script) See *kaisho*.

sumi (*boku*) 墨 The ink used in calligraphy and painting. When used by itself, the *kanji* 墨 is generally read *sumi*, but in compounds it is read *boku*, as in *boku-ga* ("ink painting").

suzuri 硯 The inkstone used for grinding an inkstick in water to prepare ink for calligraphy. The *kanji* for *suzuri* can also be read *ken*.

tanden 丹田 The center of the body at a point located slightly below the navel. A more general term for the body's central point is *hara*. See also *hara*.

tensho 篆書 A style of writing usually translated as "seal script." *Tensho* can refer to the "large seal style" that evolved from the ancient bone-and-shell script and was used on ancient bronzes, or to the "small seal style" that was developed as a unified system in the third century B.C. *Tensho* includes circles and curved lines and tends to stretch vertically.

washi 和紙 Literally, "Japanese paper." *Washi* is produced from the fibers of *mitsumata*, *kōzo* (paper mulberry), or *gampi* and is therefore composed of longer fibers than rice paper or Western wood pulp paper.

Yōki-hō 養気法 A set of exercises developed by Terayama Tanchū to encourage the flow of *ki*.

yuen-boku or *yuen-zumi* 油煙墨 Literally, "oil smoke ink." This ink is produced from the soot of burning rapeseed oil. Compared to *shōen-boku*, *yuen-boku* is a deeper black.

yūsen 湧泉 An acupuncture point located in the center of the sole of each foot.

禅の書と画　Zen Brushwork

2003年10月10日　第1刷発行

著　者　寺山旦中

発行者　畑野文夫

発行所　講談社インターナショナル株式会社
〒112-8652　東京都文京区音羽 1-17-14
電話　03-3944-6493（編集部）
　　　03-3944-6492（営業部・業務部）
ホームページ　www.kodansha-intl.co.jp

印刷・製本所　大日本印刷株式会社

落丁本、乱丁本は購入書店名を明記のうえ、講談社インターナショナル業務部宛にお送りください。送料小社負担にてお取替えいたします。なお、この本についてのお問い合わせは、編集部宛にお願いいたします。本書の無断複写（コピー）は著作権法上での例外を除き、禁じられています。

定価はカバーに表示してあります。

© 寺山旦中 2003
Printed in Japan
ISBN4-7700-2944-6